Pen and Mouse
Commercial Art and Digital Illustration

Pen and Mouse

>Commercial Art and Digital Illustration

>Edited by
>Angus Hyland/Pentagram Design

>Assistant Editor
>Roanne Bell

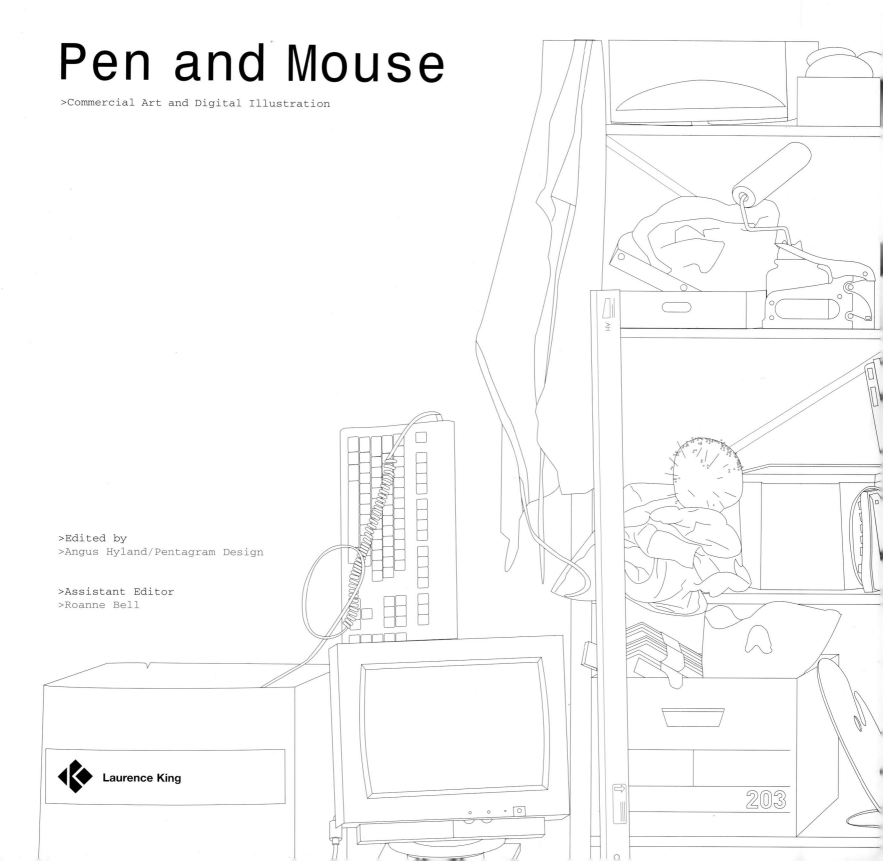

Laurence King

Introduction >

Angus Hyland
Deborah Taffler

1 Rick Poynor, Booth-Clibborn Editions, 1991
2 Rick Poynor, Booth-Clibborn Editions, 1993

3 As seen in Chris Foges'
 Magazine Design, Rotovision, 1999

4 Lewis Blackwell, 'New lines',
 Creative Review, July 1996

5 Rick Poynor, 'Illustration's last stand',
 Graphis 321, May 1999

6 Darrel Rees, Association of Illustrators (AOI)
 Seminar, held at Pentagram Design Ltd,
 November 1999

Recent years have witnessed a resurgence of interest in illustration. It has become increasingly visible in editorial design, fashion publicity, advertising, music and television graphics. This renaissance has been accompanied by a great deal of debate on the role of illustrators – adjunct to the design community or autonomous profession – and the effect of technology on their work.

This book investigates the work of illustrators whose craft occupies the space between graphic design and fine art and whose tools are increasingly digital. It also gives an insight into the profession's own perspective on the nature of its role and purpose.

For much of the last decade, illustration appeared to be in crisis. Its traditional clientele, the design and advertising sector, had turned to cheaper and more controllable alternatives. As computers became faster and software evolved to provide Freehand, Photoshop and Illustrator, designers and art directors felt enabled and empowered to produce their own imagery. The trend was compounded by broader access to and affordability of stock house pictures and copyright-free CDs such as Photodisc, crammed with images that could be manipulated and edited at will. Furthermore, a glut of books on 'new wave' typography, such as *Typography Now* [1] and *The Graphic Edge* [2], encouraged decorative typographic layouts. This was apparent in the traditional illustrator's stronghold of editorial design, as evidenced by the gestural approach in magazines, notably *Ray Gun* under the art direction of David Carson from 1992–95. [3]

As a result, illustration grew more and more anachronistic during the nineties. It was seen as parochial, expensive, impossible to edit and aesthetically at odds with the 'typo/photo' zeitgeist.

'Much that is illustrative is not produced by conventionally trained illustrators. Instead it is designers playing with Photoshop.' [4]

'It can't have been easy being an illustrator in the 1990s. As the collective attention of designers turned to ever more ingenious ways to bend type out of shape, and the computer promised total mastery of production, the lovingly-crafted, physically fragile, handmade illustration was left looking like a quaint relic from a bygone age.' [5]

This apparent slide in control from illustrator to designer prompted increasing alarm calls of extinction from educators and commentators.

'In the wake of the digital revolution, picture making in paint and ink appeared to lose ground to Photoshop collages overnight and apparently permanently. Talk of obsolescence seemed to be looming for those working in the traditional analogue way.' [6]

Yet the sources of much of the negative commentary prevalent in the 1990s were often the same individuals who perpetuated the issue. Educators still taught (and indeed many still do teach) within the comfort zone of an analog world, ignoring the new reality of a digitally aware student body. Indeed they were teaching the first generation of illustrators for whom technology was ubiquitous, and who were innately aware that the digital products causing designers and art directors to assume control were equally available to hone their own work. Those students, now professionals, see the computer and its software merely as an additional set of tools. They have maximized the opportunities that have opened up as technological limitations decrease in line with increasing affordability.

They now take advantage of control and manipulation, as evidenced by comments from illustrator Nick Higgins:

'Drawing with a mouse has now become as subliminal to me as a pen or a paintbrush always have been. The medium is better and faster for manipulation and now, cheaper.'[7]

7 Interview at Pentagram Design Ltd, August 1999

Yet it is not only the ability of the illustrator to resume control over imagery that has caused the recent resurgence in gainful employment. It is also the simple, cyclical nature of aesthetics. Not only the graphic design community but the entire media spectrum is responding to the increasing popularity of the drawn image. For example, in the fashion world:

'Nowadays, there is no better way of targeting the nation's suspicious, style-conscious taste-makers than by enlisting an accomplished illustrator with an unmistakable visual style.'[8]

8 Peter Lyle, 'Quick on the draw', The Guardian, 25 June 1999

The trend has affected all forms of communication. Information graphics have reappeared, with charts, graphs and pictograms taking on increased prominence and different emphasis by being used as much for aesthetic form as for the calibration or quantification of data. The geometric pattern and technical drawing of Karl Gerstner has been resurrected in the work of John Maeda; the work of anonymous draftsmen catalogued by Henry Dreyfuss[9] and Stiebner/Urban[10] has been revitalized as evidenced in the work of British artists Julian Opie and Michael Craig-Martin[11], both bearing witness to the cross pollination of fine art and graphic design through a modern pictorial language.

9 Symbol Sourcebook, Van Nostrand Reinhold Company, 1984

10 Picture Sourcebook, Bruckmann München, 1985

11 'Intelligence' exhibition catalogue, Tate Britain, 2000

12 Adrian Shaughnessy/Intro, Sampler, Laurence King Publishing, 1999

This technical, almost scientific approach reaches across a broad spectrum and includes record sleeves. Sheffield-based design group The Designers Republic[12], for example, adopt information graphics for their aesthetic qualities, rather than the

historical quantification or calibration of data. The trend is not exclusive to the digital world, but is also apparent in contemporary hand-drawn images, as in the work of Roderick Mills shown later in this book (pages 70–72).

The revival in the use of illustration may well be just a trend but it has served as a bridge over which illustration has crossed from the analog to the digital world.

13 Lewis Blackwell,
Creative Review, July 1996

'While illustrators don't need to use computers in their art, I suspect that it is those who do who might be in the growth area of the profession.' [13]

However, the computer is only the medium. This is apparent in the responses to the questionnaire given to all those who submitted work for this publication. The idea behind this was to provide illustrators themselves with the opportunity to comment on their motivation and working methodology, and to give their views on the role of technology and its effect on their work. A set of questions were asked, and while some of the response is ironic, consistent threads run throughout, collectively revealing a strong overall sense of identity.

Only one respondent, Faiyaz Jafri, alludes to the digital medium in his stated job title: Digital Artist; the majority prefer the traditional title of illustrator, despite inferences that this is simply because no one has thought of anything more appropriate to date. When asked how he would define illustration today, Professor Dan Fern of the Royal College of Art, London, responded:

14 'Dan Fern', interview with Rick Poynor,
Eye No. 22, Vol. 6, Autumn 1996

'It's one of those words I almost wish we could dispense with because a lot of what goes on here, and what I do myself professionally, isn't illustration. It's the provision of images to an enormous variety of contexts.' [14]

Within titles, many contributors have endorsed their role as illustrator with 'artist' or 'designer'. This blurring of the traditional disciplinary borders initially seems to indicate a commercial and chameleon-like willingness to be everything to all possible audiences, rather than to define a preference for a change in role.

Yet this potential role change should be more closely examined. Historically, the 'commercial artist' used illustrative, typographic, design and printing skills to produce entire works independently. This all-encompassing approach became increasingly redundant as the advertising and design industries evolved, with demarcated and specialized roles. More recently, however, the evolution in technology, and related affordability, has encouraged the designer-maker role to reappear. Individuals once again have the freedom to do everything from design and image creation, right through to unlimited print capability on digital printers. Perhaps some respondents

15 Robert Mason, 'Return of the picture', *Eye* No. 35, Vol. 9, Spring 2000

16 Letters, *Eye* No. 36, Vol. 9, Summer 2000

17 John Hodkinson, Letters, *AOI Journal*, August/September 2000

are gravitating to this more pluralistic approach, rather than simply attempting a more commercial title, as demonstrated by Rian Hughes' remarks in a letter to *Eye* magazine, responding to an article about the pictorial tradition in illustration[15]:

'Much of the debate seems to focus around a lament for a somewhat outdated and narrow concept of illustration that is seen as mainly editorial and has little long-term historical basis. This view seems to have arisen with the compartmentalisation in the past 50 years of "commercial art" into specialist areas, each presided over by a different "expert". Cassandre and McKnight Kauffer, Abram Games, Toulouse-Lautrec, Victor Moscoso or the Stenberg brothers would not have considered themselves only "illustrators", who (as today) might be briefed by an art director, then give over their finished work to a separate typographer, and maybe even a separate layout artist.

If the computer is eroding certain areas of illustration, it is because it has given the complete power of control back to a single author. Every time I use a font I have designed myself in a piece, I think of the extended control I have over the most esoteric and detailed parts of the image-making process – a control that was unthinkable ten years ago.'[16]

There is a school of thought that the traditional title of 'illustrator' serves as a perfect descriptor, both in a historical and contemporary (and digital) context. The dictionary definition of illustrate – make clear by examples, explain, elucidate by drawings or pictures, with the Latin root lustrare, to 'light up' – is surely the ideal description for this sector. Arguably, the first illustrators or 'commercial artists' were monks who indeed 'lit up', or illuminated, text with explanatory imagery. This communicative slant to the title is particularly evident in responses from artists such as Anthony Burrill, who wants to use illustration 'to help build a new language of visual communication'; while Roderick Mills uses the notion as a title: 'visual communicator'. John Hodkinson, Course Leader at the University of Central Lancaster, sees only relevance in traditional nomenclature:

'…I have no problems with the term 'illustration'. It is, I believe, that wonderful region which can still contain all of the best traditions and innovations which were the glory of the British Art school, so long as you keep the skull and crossbones flying from the mast and treat all waters as your own by right.'[17]

In response to the question 'Why do you do what you do?', a minority of respondents claim to be motivated by potential celebrity, with financial gain seemingly the least concern. Other motivation to create imagery is suggested as more conceptual, with artists such as Lucy Vigrass and Alex Williamson defining themselves as communicators and problem-solvers. For the majority, the root of the illustrator's motivation for creating images is twofold: pure enjoyment and inherent talent.

18 Chris Sharrock, 'Drawing, I love it',
 AOI Journal, October/November 2000

'Drawing. It's like being God – you make a world, in your own image, where nothing existed before. When it is drawing for illustration, it's a bit like the way the biblical God created the world, in that the words come first....Where once there was nothing but the blank empty space of a piece of paper, there is now a world. A world that may be dependent on the reality all around, but a reality that has been filtered through the creator (be they an illustrator or some other, lesser form of artist). Drawing, I love it.'[18]

The initiator of the drawn image may now use the same engine as the person commissioning the work, but the skill sets of the two groups are specific and distinct. The basic craft skills of the image-maker are still vital and it is these specific skills that distinguish illustrator from graphic designer.

19 Rick Poynor,
 Graphis 321, May 1999

'There is a hunger for original modes of visual expression and good reason for thinking that, in a renegotiated partnership, design and illustration might offer a way forward. Illustration's territory is the image and it was presumptuous of designers to imagine that Freehand and Photoshop were enough.'[19]

Inspiration, unsurprisingly, comes from everything. From the local environment, travel, family, mentors, peers and indeed from the imagination of those who have such keen powers of observation. Anthony Burrill also alludes to the nature of the brief in his response, being inspired by 'other people's thought processes'.

On the all-important inquiry into the difference between craft and technology, Spencer Wilson perhaps summarizes best on behalf of the majority of respondents: 'Craft is skill that is required, whereas technology is a tool to be used'.

Anthony Burrill's observation that 'technology enables craft to develop into previously unused areas' supports the view that the age of technology has increased opportunities for image-makers, rather than diminishing their role, a notion that was previously stated at the AOI Seminar, Drawing the Line, where the future of illustration was debated.

20 Darrel Rees, AOI Seminar, held at
 Pentagram Design Ltd, 20 November 1999

'I don't see the advance of the digital world as a threat....In fact, for those so inclined, the great range of affordable software and high powered computers offers the opportunity to add another dimension to their work....'[20]

Answering the questionnaire for this book, Kinsey responded that neither craft nor technology can survive in isolation. 'Craft uses technology. Technology comes from experiments with crafts. One won't stand without the other.' Understood in the broadest context, this statement has always been true, as suggested in the *AOI Journal*, October/November 2000.

21 Lawrence Zeegen, *AOI Journal*,
 October/November 2000

'The birth of cinema did not kill off theatre, the invention of the gramophone did not murder live music and the computer has not spelt (sic) the end for the hand drawn/created image. The two exist side by side and often some of the best work is a mix of traditional and digital media. The ability to scan drawings, manipulate colours and use effects can add to the toolbox rather than limit it. If you are unsure about how effective the kit can be take a look around at the world of illustrators: George Snow, Joe Magee, Andy Martin, Marion Deuchars etc. etc. Great artists in the past have welcomed new technology, embraced it and used it to push their work in new directions; Hockney picked up the Polaroid, Warhol reinvented screen printing and Hirst has started to produce limited edition prints from artwork that exists only on disk.'[21]

The response to illustrators' techniques, current and past, loosely follows the general industrial evolution from pen to mouse. Most started their illustrative careers with pen, pencil, brush, ink and paint in hand, with many now involving one or more of the available electronic tools, including Photoshop, Illustrator and Flash. Some have embraced the digital world wholeheartedly; others have chosen to remain hands-on. Yet interestingly, most comment and discuss traditional techniques as the basis of work and merely mention 'the computer' as one of the tools they use. Many do not mention technology at all, including those for whom the digital route has become the norm, further compounding the notion that the tools are merely a means to an end.

From: Paul McNeil / To: The Author

What do you use as a job title?
>Artist/illustrator (although it says artist in my passport in the hope that authorities will feel sorry for me).

Why do you do what you do?
>To make people happy.

What inspires you?
>Other artists and art in general (strictly modern art that is). Also the concept of breaking down the notion of what is deemed acceptable art.

Craft/Technology: What is the difference?
>No difference as far as I can see. Anything good generally has a good thought behind it irrespective of how it was produced. I presume that a loom was once considered 'high-end technology' just as a computer is now. I don't have any steadfast theories on computers; it's just something that's in my house that is ideal for producing quick, colourful images. But there is more to this question... see below

Which techniques do you use?
>I procure an evocative image from my past (often a photo) and then try and reproduce it crudely using a computer mouse and a simple drawing program. I will tweak the colours until I get it looking good and then I will draw the image on to canvas and paint it up colour-by-numbers style. Drawing with a mouse is sloppy and inaccurate like drawing with your left hand. The results can be surprising. It's also instantaneous and rewarding. I do dozens of images before I decide to paint one up. Which brings me to the painting: any computer boffin will say 'Why doesn't he just print them out on to canvas?' Well, I could but it's much more therapeutic to paint and I enjoy using my hands as well (which it's fair to say is the craft side of it).

Are these the techniques that you have always used?
>No, not really. They are techniques I currently use. But I want to keep things changing, with or without the computer. It's just a tool that can take over your life.

>1.1/Satday

>1.2/Monaro

>1.3/Birriga Road

>1.4/Surf

>1.5/Bad Thorts

>1.6/Chuckin the Peace Sign

From: Anthony Burrill / To: The Author

What do you use as a job title?
>Moderne artist.

Why do you do what you do?
>To help build a new language of visual communication.

What inspires you?
>The by-product of other people's thought processes.

Craft/Technology: What is the difference?
>Technology enables craft to develop into previously unused areas.

Which techniques do you use?
>Drawing, photocopying, photography, scanning.

Are these the techniques that you have always used?
>Yes, apart from scanning (this is more recent).

>2.1/Here is a Shape

>2.2/Gallery Chair 1

>2.3/Gallery Chair 2

>2.5/Man

>2.6/Woman and Ironing Board

>2.7/Line Man 1

>2.8/Line Man 2

From: Kjeks – Nina Klausen & Lill-Hege Klausen / To: The Author

What do you use as a job title?
>Illustrator and web designer.

Why do you do what you do?
>For the fun of it.

What inspires you?
>People who are genuinely strange, weird people.

Craft/Technology: What is the difference?
>No idea!

Which techniques do you use?
>At the moment we draw everything by hand, then in Illustrator.

Are these the techniques that you have always used?
>No, the technique varies with the style we're going for.

>3.1/Picture

>3.2/Couple

>3.3/Outdoors

>4.1/Red Yellow Blue

>4.2(right)/Tomo 1
>4.3(below)/Spacial Density 4
>4.4(far right)/Sony Xmas; client: SonyDrive

From: Jeff Fisher / To: The Author

What do you use as a job title?
>Illustrator/designer.

Why do you do what you do?
>Optimism/delusion.

What inspires you?
>Painting, music, sculpture, photography, 20th-century British illustration, history,
insane art, popular art, etc. Anything interesting by anyone doing anything interesting.

Craft/Technology: What is the difference?
>There is no difference. Illustrators, designers, painters, photographers are interested
in producing a compelling image. No-one cares by what method they do it.

Which techniques do you use?
>Line, tone, texture, shape, contrast, colour.

Are these the techniques that you have always used?
>Yes, everyone does.

>5.1/Untitled

>5.2/Untitled

JF

>5.3/Untitled

From: Ian Wright / To: The Author

What do you use as a job title?
>Painter/decorator.

Why do you do what you do?
>No real answer to this one; still working on it.

What inspires you?
>Inspirations: music/people/ideas of what could
be/literature/mistakes.

Craft/Technology: What is the difference?
>Depends on whose hands they're in; I like to abuse both.

Which techniques do you use?
>A combination of drawing and various processes, some mechanical.
I prefer to keep it 'lo-fi' and somewhat accidental where possible.

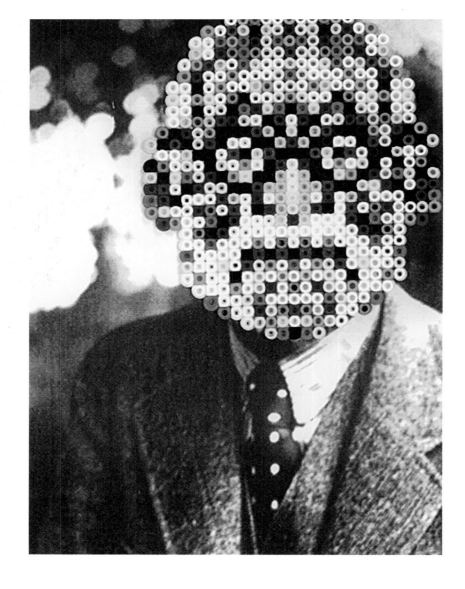

>(top)/by Ava Wright, age 9
>6.1(above)/Art Ensemble of Chicago
>6.2(right)/Freud

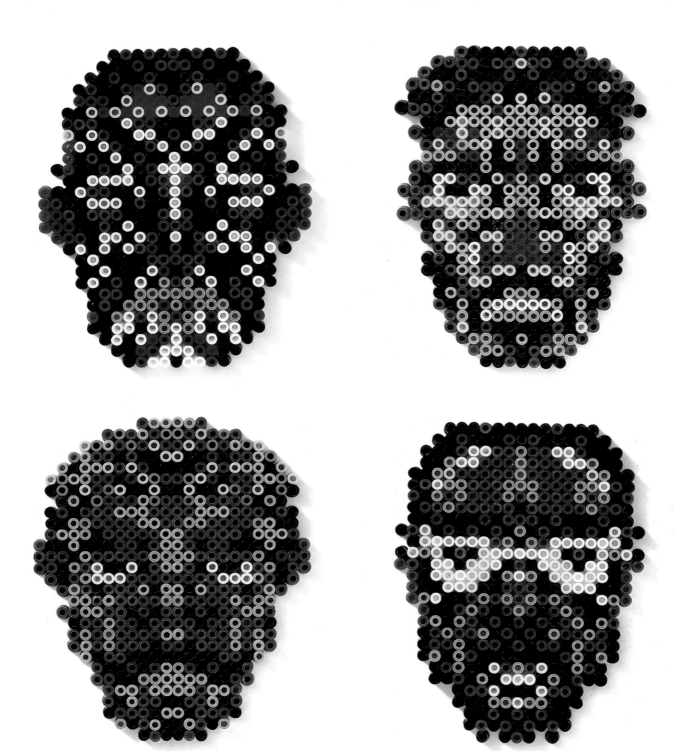

>6.3-6.6/Art Ensemble of Chicago

From: Alex Williamson / To: The Author

What do you use as a job title?
>Artist.

Why do you do what you do?
>To say what I want to say.

What inspires you?
>Big pay cheques and good books.

Craft/Technology: What is the difference?
>Technology frees you up and gives you access to different things, yet
doesn't quite live up to the qualities that original craft can bring. I
think you have to know the craft side to get the most out of the technology.

Which techniques do you use?
>Photography, collage, photocopies, silkscreen, Photoshop.

Are these the techniques that you have always used?
>Pretty much, though the digital side is newer to me.

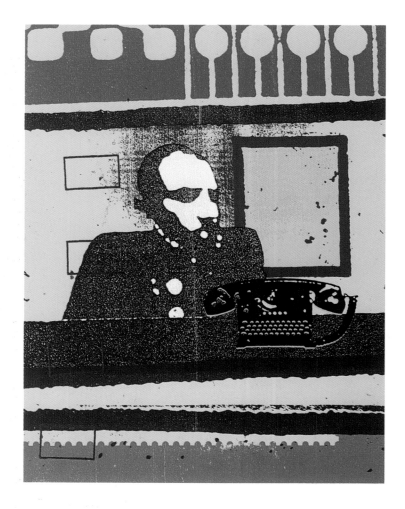

>7.1/Watching You >7.2/The Office

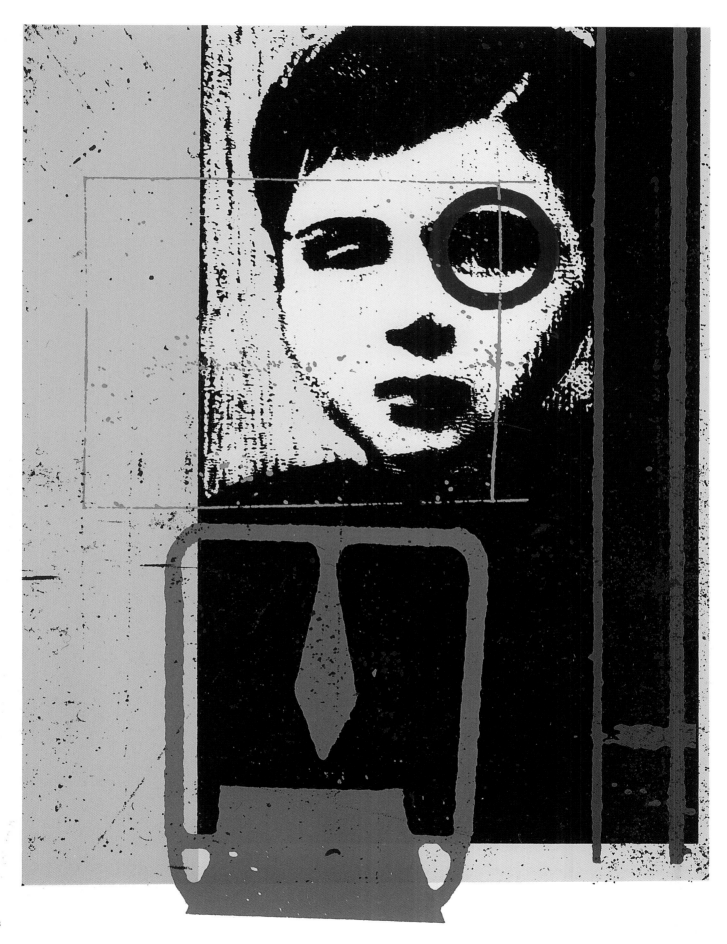

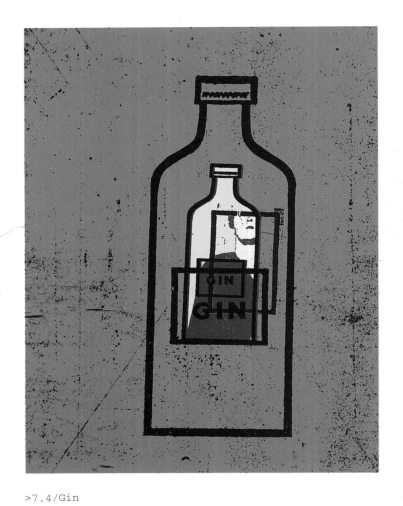

>7.4/Gin

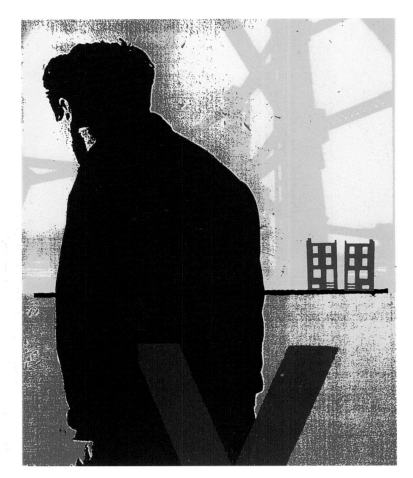

>7.5/Broken Man

From: Tommy Penton / To: The Author

What do you use as a job title?
>Illustrator/artist.

Why do you do what you do?
>That's a stupid question, don't insult my intelligence.(The serious answer is: I've
wanted to be an artist from the day I could draw, and I'm dikslekslik.)

What inspires you?
>I'm inspired by my generation and its culture.

Craft/Technology: What is the difference?
>Computers are simply a tool I use to further my art.

Which techniques do you use?
>Photoshop, Illustrator, Flash.

Are these the techniques that you have always used?
>No, I've experimented, and will always experiment to develop my art.

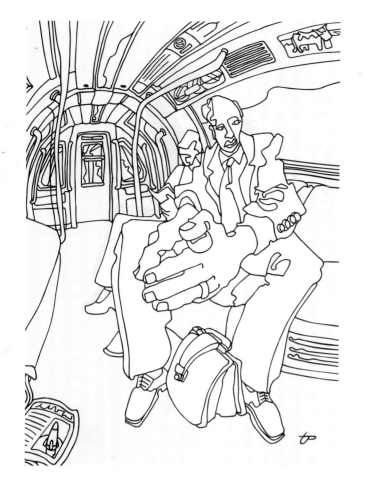

>8.1/Untitled

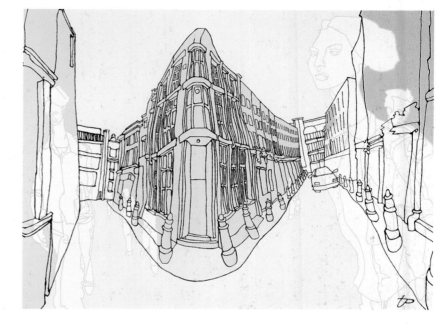

>8.2/Newburgh Street

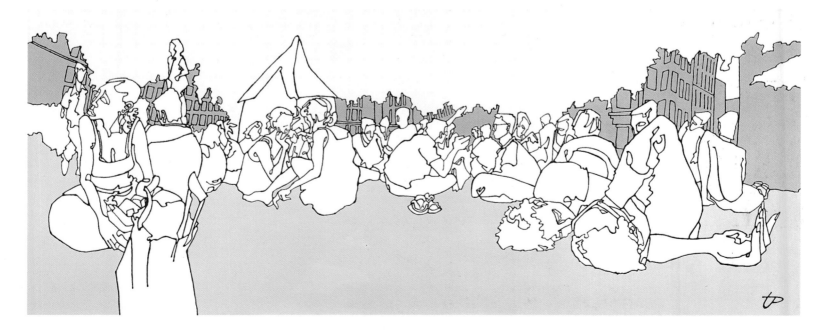

>8.3/Soho Square

From: Shonagh Rae / To: The Author

What do you use as a job title?
>Illustrator.

Why do you do what you do?
>Through a process of elimination.

What inspires you?
>Change.

Craft/Technology: What is the difference?
>Craft is about subtlety, and technique is concerned more with convenience.

Which techniques do you use?
>Drawings and collage reworked digitally.

Are these the techniques that you have always used?
>I have always worked in a similar way, though prior to using the computer
I relied more on print-making.

>9.1(above)/Aerial,
commissioned by HSAG Design
>9.2(right)/Book jacket for 'Midnight in
the Garden of Evel Knievel' by Giles Smith

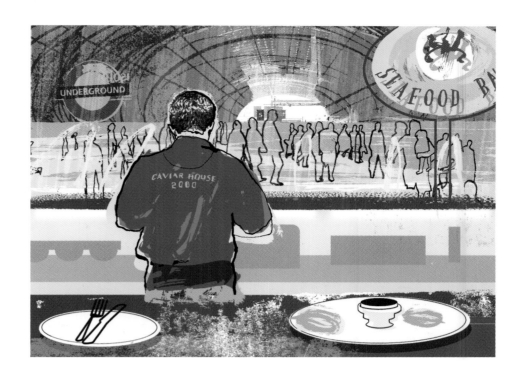

>9.3/Caviar House,
commissioned by The Independent

>9.4/Zeta, commissioned by The Independent

>9.5/Book jacket for 'Lost in Music'
by Giles Smith

>9.6/IKEA, commissioned by IKEA Room Magazine

From: Miles Donovan / To: The Author

What do you use as a job title?
>Illustrator.

Why do you do what you do?
>The enjoyment of producing images.

What inspires you?
>Good music, New York, London Town, Emma Peel.

Craft/Technology: What is the difference?
>Craft provides a satisfaction that technology cannot and will never provide.

Which techniques do you use?
>Photoshop for computer-generated imagery, stencils, spray paint, and acrylic on
canvas/paper for paintings.

Are these the same techniques that you have always used?
>They have always been the materials and techniques I have used, although since
acquiring a Mac my work has become more computer-generated.

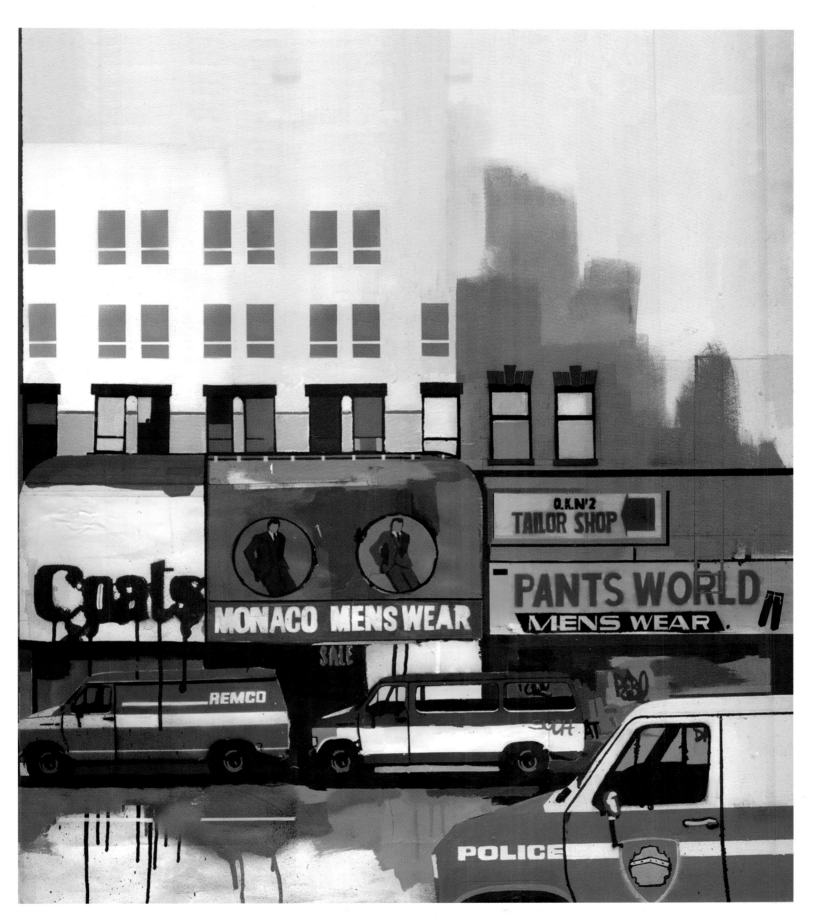

>10.1/New York Street Scene 1

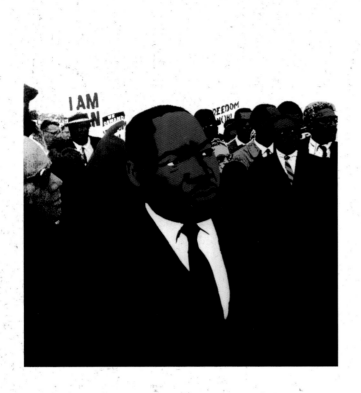
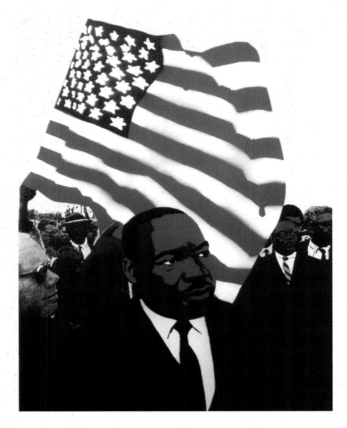
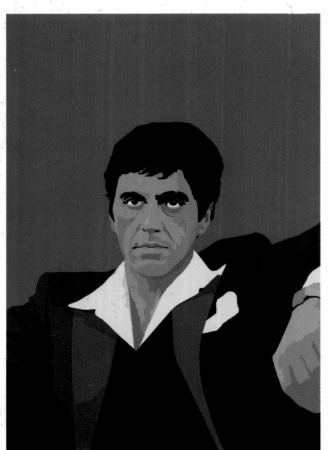
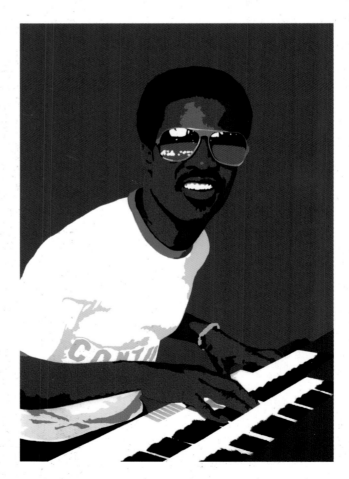

>10.2–10.5(from top left)/MLK 1, MLK 2, Scarface, Stevie Wonder

From: Chris Kasch / To: The Author

What do you use as a job title?
>Freelance illustrator.

Why do you do what you do?
>Painting is the only thing I've ever felt confident about doing. I'm very pleased to work in a profession I enjoy.

What inspires you?
>Sixties and seventies popular culture, films, record covers, fashion and interior design set in a modern context.

Craft/Technology: What is the difference?
>With regard to digitally creating images, I think technology should be used as a tool. The best computer-generated images I have seen are the ones where I didn't instantly register that the work was done on a computer. In other words, technology didn't stand in place of the creative process. So, in answer to the question, I don't think there is any difference between craft and technology.

Which techniques do you use?
>Acrylic on paper.

Are these the techniques that you have always used?
>I have pretty much always used acrylic. I used to be very loose and painterly but changed fairly rapidly in the transition from being a student to a professional illustrator.

>11.1/Batteries Not Included

>11.2/Soul Mates, commissioned by You Magazine

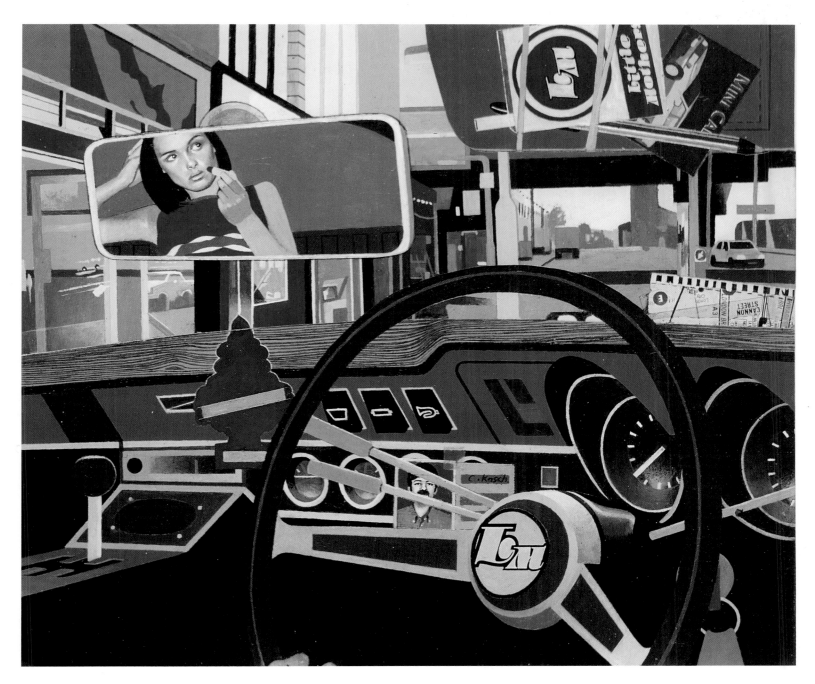

>11.3/Little Mothers: Your Twisted Sister record sleeve for Island Records

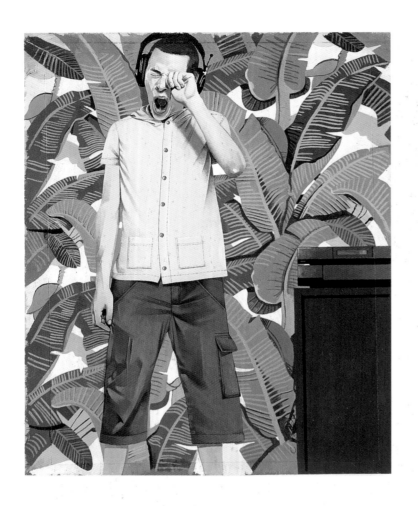

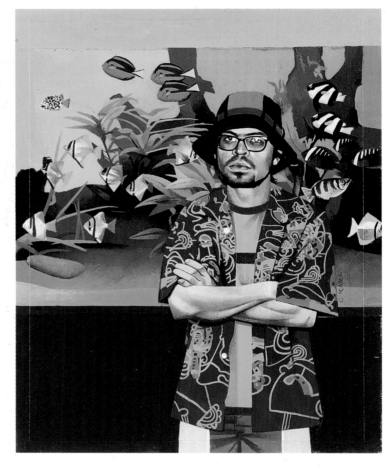

>11.4/Promotional postcard for Mineral Clothing

>11.5/Promotional postcard for Mineral Clothing

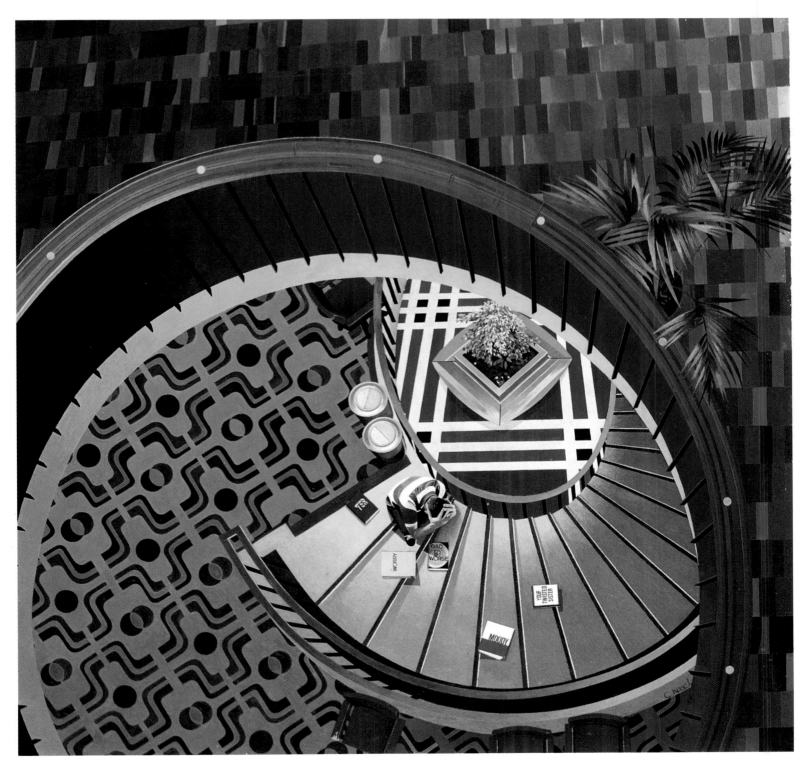

>11.6/Little Mothers: The Worry record sleeve for Island Records

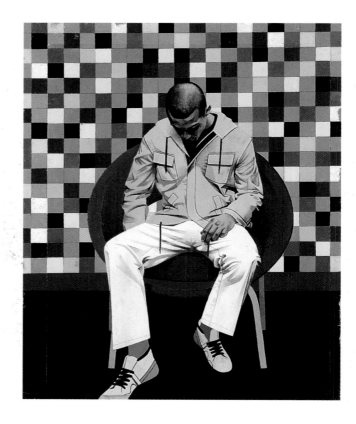

>11.7/Promotional postcard for Mineral Clothing

From: Graham Rounthwaite / To: The Author

What do you use as a job title?
>Illustrator/graphic designer.

Why do you do what you do?
>Hype.

What inspires you?
>London.

Craft/Technology: What is the difference?
>There's no substitute for craft. Whether you work on computer or not, you still start from a blank piece of paper or a blank screen. To do anything good you need an idea.

Which techniques do you use?
>Pencil, paper, rubber, computer.

Are these the techniques that you have always used?
>It changes all the time.

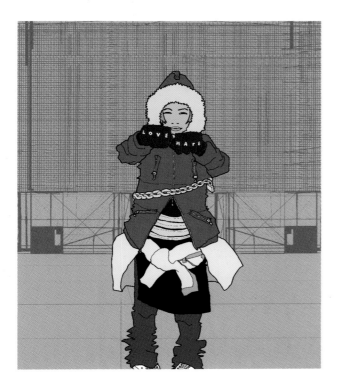

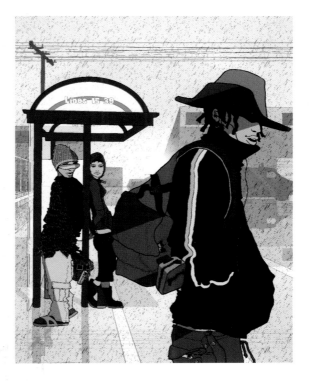

>12.1/Off-centre

>12.2/Levi's SilverTab advertising campaign

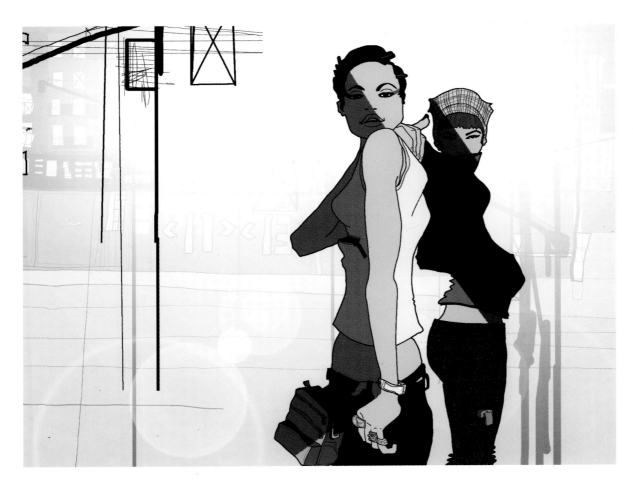

>12.3/Levi's SilverTab advertising campaign

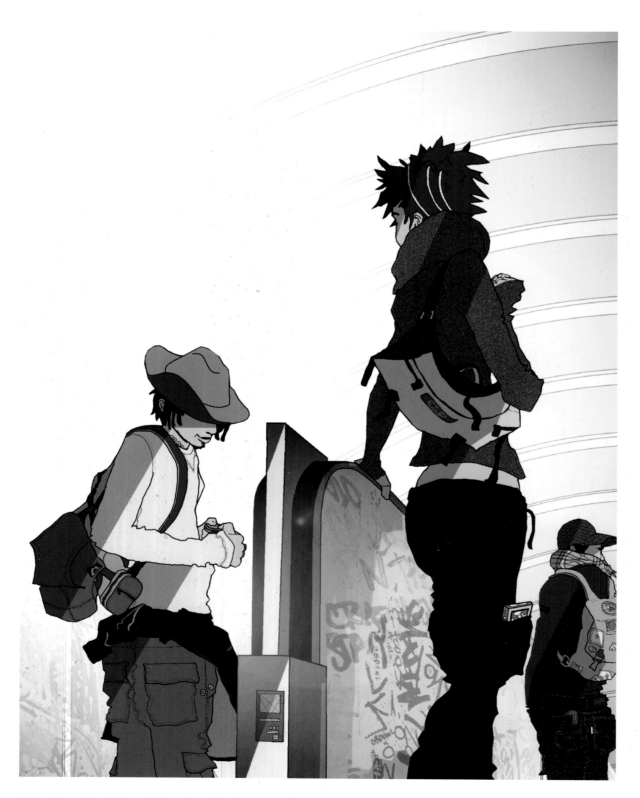

>12.4/Levi's SilverTab advertising campaign

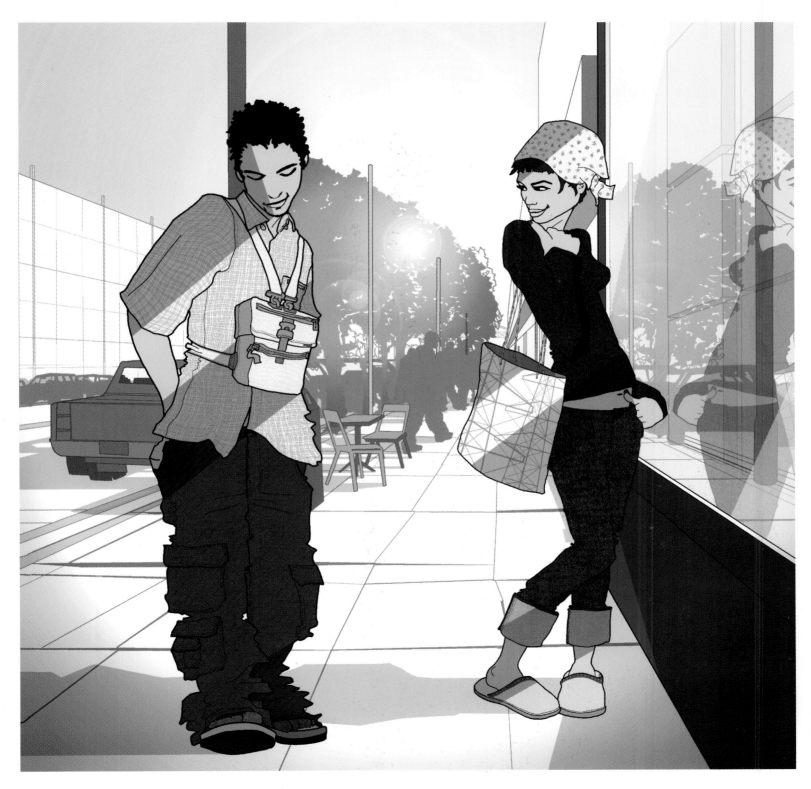

>12.5/Levi's SilverTab advertising campaign

From: QuickHoney - Nana Rausch & Peter Stemmler / To: The Author

What do you use as a job title?
>Illustrator/designer.

Why do you do what you do?
>It's fun!

What inspires you?
>New York. Boyfriend/girlfriend. Nature. Coffee. Friends. Video games.

Craft/Technology: What is the difference?
>They are two different things. I see a million differences there....

Which techniques do you use?
>Tracing photos in Illustrator. Pixel by pixel in Photoshop.

Are these the techniques that you have always used?
>We started drawing by hand, and then we figured that the computer style is much
more related to the present and the future, and that it makes more sense to us.

>13.1/Miss June >13.2/House Love Sex

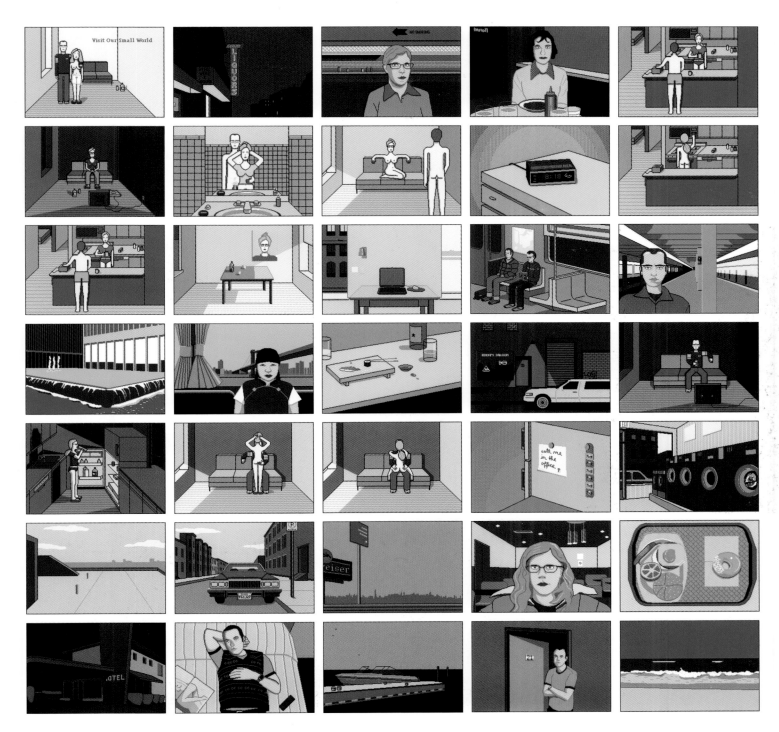

>13.4/Psycho

>13.5/The Dentist

```
                ...4;XC4.
              .~CDD$$$$$$8S;
             IDS$$$$$$$$$D$S.
           ~SD$$$$$$$$$$$$$$O.
         ;4$$$$DO44CX;+S8DD$$$C:-
        XD$$$SC;+I~~~~:;XCS$$$$:
        O$$$8C;+:~~...~~I:;CD$$$C.
        ;$$$SX;:I~------~I:+;O$$DX
        :$$$CXCX4C+~~~~;CCX;4$$D.
         C$D;XCS84C;~:XCSS4CX$$8.
        .;O8+:;XXXXX:;XXCCC;+8DX-
        ~;4O+::::::XX+;X+:::++SC;I
        -;ODXX;:I+C4;C4;~I+;X8S+I
        ;X84CX;+X44CC4X++;XCDX;-
        .+4S44CCSOSC4OSCCC4SSX-
         .SO44C4444CCCX C4S8:
          ;DOO8CXCCXXCSOODD.
          .O$$$DSCCCCOD$$$S.
          .C8$$$$DDDD$$$DSC.
          .CSOD$$D$$$D8S44C.
          ..4444SOSCC444CC44:
...   .. .  .:XCSS4CC44CCCCCCC4S4+-.
...........-I;444SSS44CCCCCCC44SS4CCX;~..    ..
.......-I;XCCXCS4444S4C44444SSSS44CCC44CX+~....
..-~:XCSS4C4444S44444CCCCC4O8OSSSSS44SSO44CX:~
+CC4SOSS8OOSS8D8ODD8OOOSO8DDD8OOOSSSSSSOOOSSS4C
S8888888D8O8OO888DD$$$$$$SDDOOOSOOSOOOSOOOOOSC
8$D$DDDDDDD888DDD8D$$$$DDD8O8888888DD88O8O8DX
.I+XXXXXCXXXCXCCCCX4444SOS4SO8888DD8OSDDDOD888-
                                   ...
```

From: Spencer Wilson / To: The Author

What do you use as a job title?
>Illustrator.

Why do you do what you do?
>My inspiration comes from a new book or magazines or just by talking to friends.

What inspires you?
>I'm fortunate enough to have friends doing similar things who live within walking distance. It's talking to them that I find helpful, and the competition keeps me motivated.

Craft/Technology: What is the difference?
>Craft is skill that is required, whereas technology is a tool to be used.

Which techniques do you use?
>I work in different styles and use a variety of different tools to produce my work depending on the commission. For example, one job might involve a simple tracing, another might be a hand-drawn image on a badly printed background. I like to keep my method of producing work fluid so that I stay interested.

Are these the techniques that you have always used?
>Yes, they just evolve to suit the needs of the work.

>14.1/Scientists

>14.2/Crush Boy

>14.3/Business

From: Green Lady – Gary Benzel & Todd St John / To: The Author

What do you use as a job title?
>No job title.

Why do you do what you do?
>We like to create drawings and prints of subject matter that we think is interesting or important or amusing.

What inspires you?
>Photos of things and actual things we see in real life.

Craft/Technology: What is the difference?
>Craft is more like macramé. Technology is more like robots.

Which techniques do you use?
>Drawing mostly, then using computers to colour and retrace. Computers are also good for repeating shapes.

Are these the techniques that you have always used?
>No. It used to be more drawing and cut films and inking, until computers made shapes and colouring easy.

>15.1/Suits, originally created for Arkitip

>15.2/Trunkasaurus,
originally created for Arkitip

From: Lucy Vigrass / To: The Author

What do you use as a job title?
>Illustrator.

Why do you do what you do?
>I enjoy the problem-solving process of creating images for text or other
people's specifications.

What inspires you?
>My work is heavily influenced by printed ephemera which I have collected
over the past few years. I love crudely printed material, often with mis-
registered colours.

Craft/Technology: What is the difference?
>From a personal point of view I find that working only on the computer
creates too perfect an image. I like the uncertainty of the technique I use,
however I do enjoy the luxury of finishing work on the computer.

Which techniques do you use?
>I produce flat colour prints by screen-printing through paper cut stencils.
It is a technique that produces crude and imperfect images but it's the
glitches that I like.

Are these the techniques that you have always used?
>This is a technique I have developed over the past few years.

>16.5/Tower

From: Paul Davis / To: The Author

What do you use as a job title?
>Artist/illustrator.

Why do you do what you do?
>I like to draw a lot.

What inspires you?
>Life itself.

Craft/Technology: What is the difference?
>Craft has fewer letters.

Which techniques do you use?
>Draw, paint, scan, colour in on G4.

Are these the techniques that you have always used?
>Not the last two.

LISTEN TO REASON,
YOU IGNORANT FOOLS.

DAVIS 99

JESUS
on
www.copyrightdavis.com

FAKE LONDON
GENIUS

>17.1(top left)/Untitled
>17.2(top right)/Jesus
>17.3(right)/Advertisement for Fake London Clothing

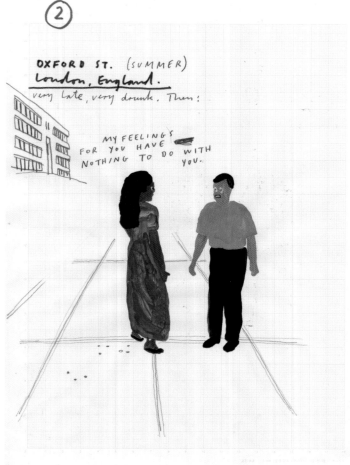

OXFORD ST. (SUMMER)
London, England.
very late, very drunk. Then:

MY FEELINGS
FOR YOU HAVE
NOTHING TO DO WITH
YOU.

>17.4/My Feelings for You

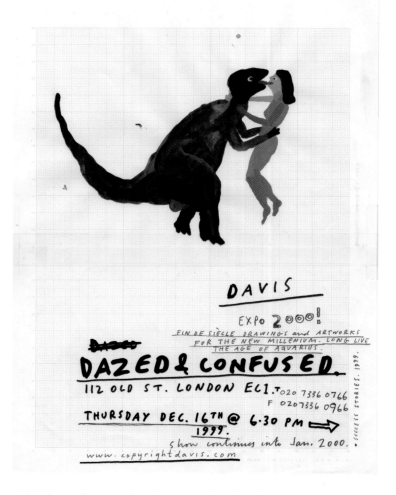

DAVIS

EXPO 2000!

FIN DE SIÈCLE DRAWINGS and ARTWORKS
FOR THE NEW MILLENIUM. LONG LIVE
THE AGE OF AQUARIUS.

DAZED & CONFUSED.

112 OLD ST. LONDON EC1. T 020 7336 0766
 F 020 7336 0966

THURSDAY DEC. 16TH @ 6.30 PM ➡
 1999.
 Show continues into Jan. 2000.
www.copyrightdavis.com

• SUCCESS STORIES. 1999.

>17.5/Dazed & Confused party invitation

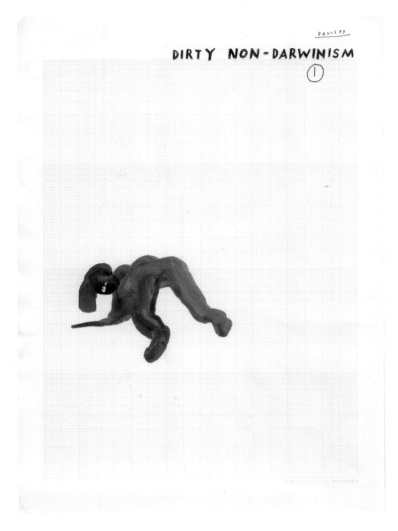

>17.6/Dirty Non-Darwinism

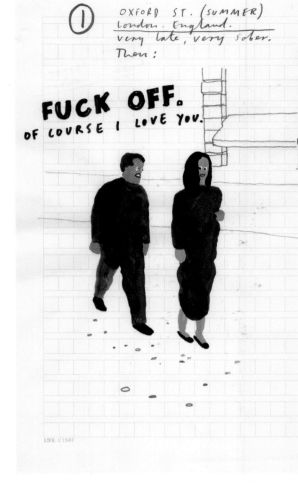

>17.7/Fuck Off. Of Course I Love You

>17.8-17.12/Cock, Ass, Beaver, Tit, Pussy; book project. Design by Nick Jones

From: Joe Magee / To: The Author

What do you use as a job title?
>Depends on who's asking.

Why do you do what you do?
>I think I have a flair for creating images, and I enjoy it.

What inspires you?
>I wish I knew. People, music, good art.

Craft/Technology: What is the difference?
>I see craft as the mastering of a medium. Technology is a medium, amongst other
things (I think it is also a tool and often a subject - which can make its role
confusing). The craft in using technology to create art is, as with all crafts, a
process which involves a lot of time, learning, experience and ultimately, but not
necessarily, experiment. Good craft will exploit the medium effectively. In the
case of technology, this is again problematic, as it covers a vast range of usages:
for example, time-based arts require a whole set of skills which previously were
the domain of separate craftspersons, such as editing and cinematography. For me,
it is essential to have a vision before engaging creatively with a computer,
otherwise the work will become lost in the digital process.

Which techniques do you use?
>That would be telling.

Are these the techniques that you have always used?
>No.

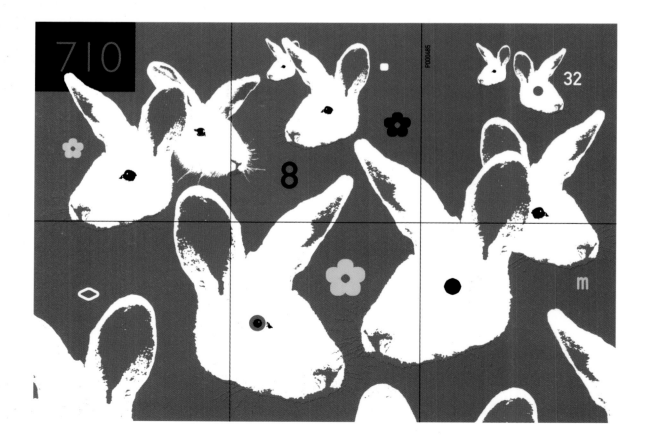

>18.1/Rabbit Function

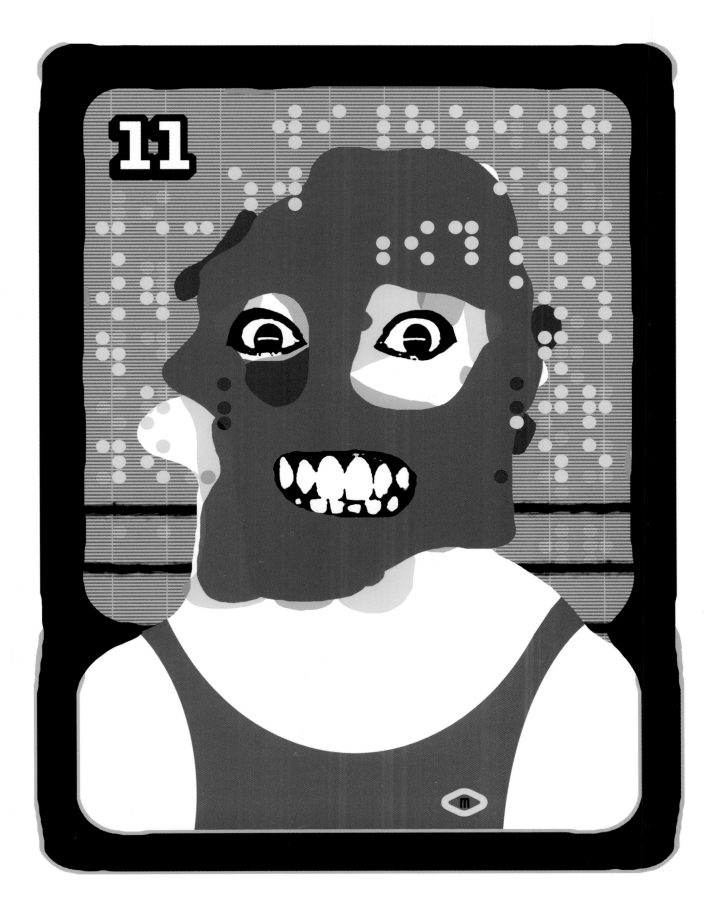

From: Kinsey / To: The Author

What do you use as a job title?
>Modern Socialistic Illustration, Graphic Arts, Design, Moving Visual Pieces.

Why do you do what you do?
>I don't know. I didn't care about it until I entered art school to escape from my life at the time and found what was inside and decided to take it seriously. Since my life was set in motion from there I don't want to ever stop. It makes me understand my expression.

What inspires you?
>Motivated creative people making shit happen. Natural free form and abilities.

Craft/Technology: What is the difference?
>A Craft uses Technology. Technology comes from experiments with crafts. One won't stand without the other.

Which techniques do you use?
>Digital, acrylic, spraycan, wheatpaste, pen and ink, camera, street application.

Are these the techniques that you have always used?
>For about ten years now. I always liked to draw when I was little with pencils, brushes and anything I could get my hands on but it just didn't have any reason.

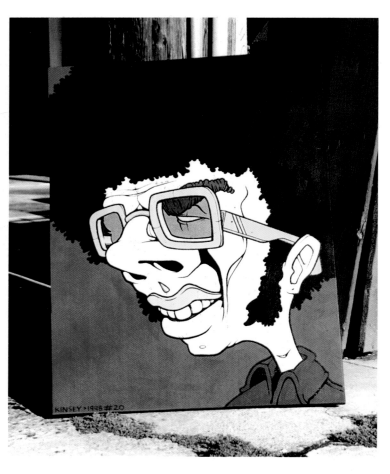

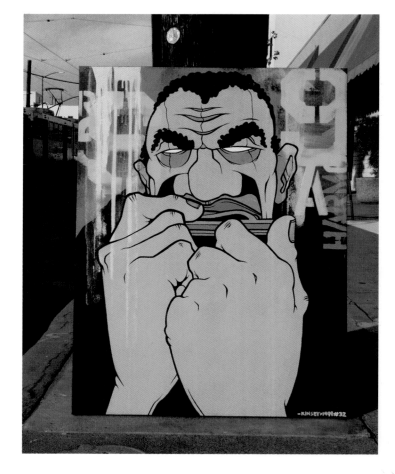

>19.1/Afro

>19.2/Harmony

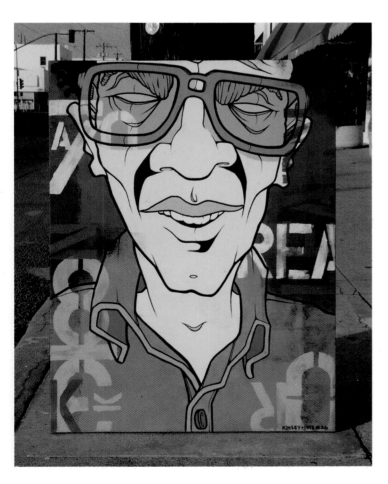

>19.3/New Era

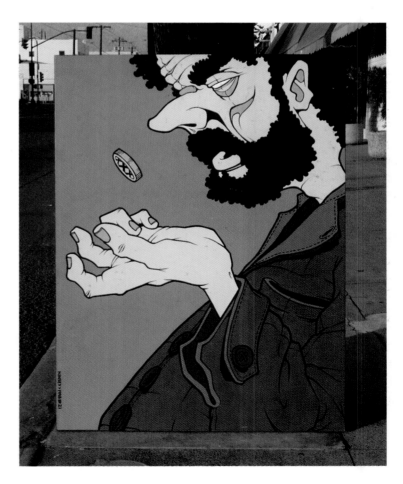

>19.4/Token

From: Marion Deuchars / To: The Author

What do you use as a job title? / Why do you do what you do? / What inspires you? / Craft/Technology: What is the difference? / Which techniques do you use? / Are these the techniques that you have always used?

>commercial artist, image maker, illustrator, graphic artist, painter, lecturer, idealist, communication, unpredictable, illuminating, conscientious, encouraged, foolish, stumbled into, can't do anything else, fast, easy, agonizing, curious, ambitious, privileged, messy, playful, helpful, sociable, growing, good holidays, funny, responsible, varied, accessible, late start, late finish, freedom, miroslav holub, colour, light, smell, great art, local art, inventiveness, dexterity of line, mexican markets, wit, melody, hermann hesse, studs terkel, galbraith, dan graham, soft elements, hard elements, untamed, buildings, language, sex, blue things, duritti column, honesty of line, streets, tequila, 73 bus, habits, observations, flowers, wooden things, fabriano, rhythm, humour, gravel, sea, take-offs, arp, doctor strangelove, bed, günter grass, photocopies, richter, felt-tip pens, parks, chairs, graffiti, love, paint and more paint, charcoal, big fat brushes, stencils, scrap, contrasts, brockman, things that move, tidying desk, tidying plan chest, david cosby, slag heaps, hands, de bono, philip guston, vernacular, good shoes, proportion, lynch, brick lane, mark e smith, newspapers, walking, skipping, things in pairs, arvo part, encyclopedias, robert frank, dodecahedrons, craft - drawing slowly, painting fast, changing colour, inspiring, contrasts, ideas, mistakes, mixed media, workmanship, training, skill, emotion, process, moving stuff, spontaneous, satisfaction, tidy, hands-on resourceful, form, safe, old hat, innovative, predictable, honesty, beauty, reflective, badly drawn, the power of a drawing, earnest, technology - exciting, new, easier, innovative, quick, opportunities, new directions, layers, expansion of skills, lazy, bad back, bad eyes, corrections, speed, crashes, frontier, unfamiliar, colour printers, scanning stuff, new pencil, freedom of location, virus, rebuilding desktop, ubiquitous, boring, emotionless, convenient, filters, efficiency, detail, straight lines, tidy, changing colour, changing scale, dynamic, addictive, liberating, predictable, fear.

>20.1/Commissioned by New Scientist magazine

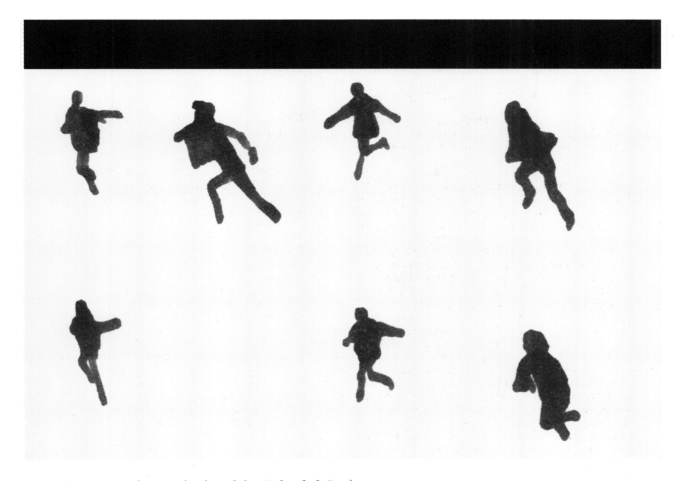

>20.2/Summer card, commissioned by Unleaded Design

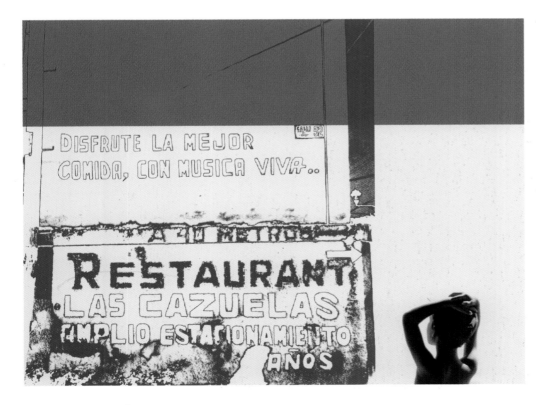

>20.3/Les Cazuelas

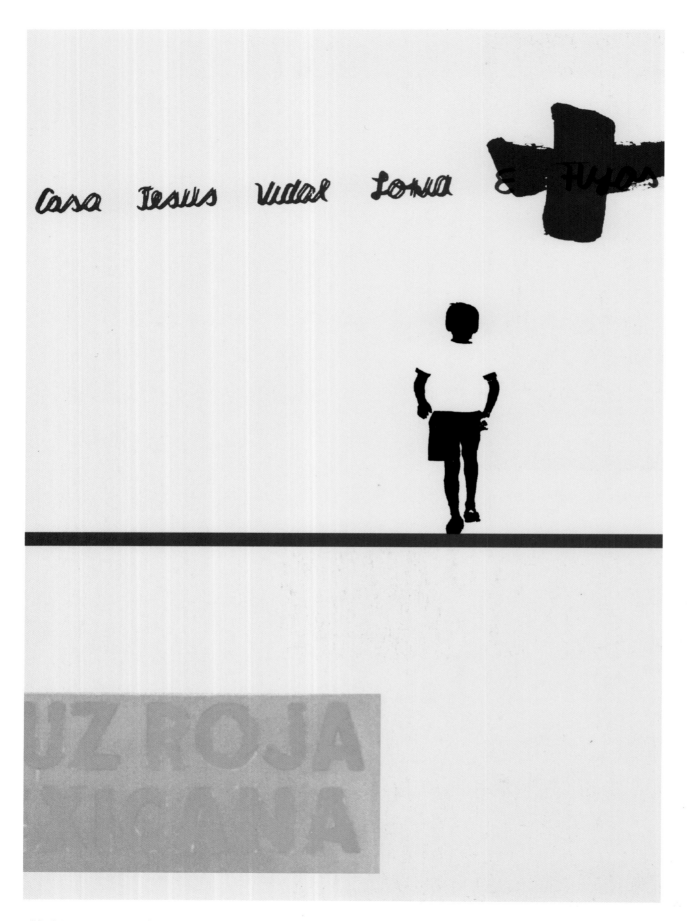

>20.4/Casa Jesus Vidal

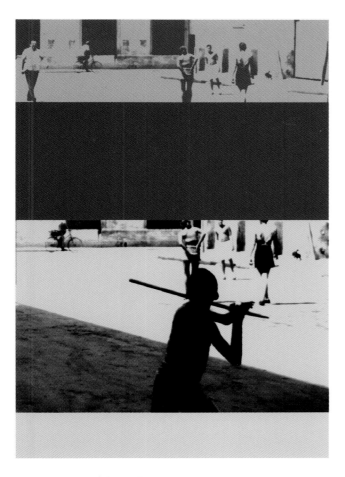

>20.5/Baseball, Cuba

>20.6/Adam at Beach

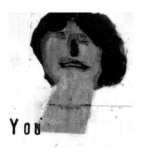

From: Ceri Amphlett / To: The Author

What do you use as a job title?
>A visually busy person.

Why do you do what you do?
>It's my calling.

What inspires you?
>The things people say and do.

Craft/Technology: What is the difference?
>You can be crafty with technology. You can be technological with craft.

Which techniques do you use?
>Acrylic on acetate.

Are these the techniques that you have always used?
>Mostly.

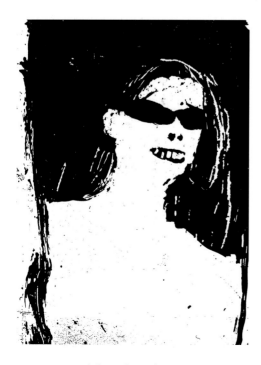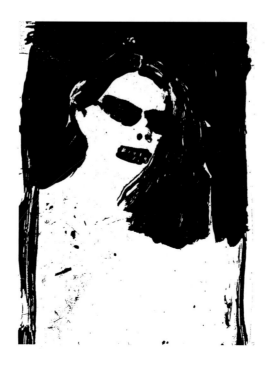

>21.1–21.6/The Changing Faces of Lucy

From: Roderick Mills / To: The Author

What do you use as a job title?
>Illustrator/visual communicator.

Why do you do what you do?
>I have always created visually. Sometimes it is the only means to
express/communicate thoughts and ideas. Even if it is just through the simple
use of pen and paper.

What inspires you?
>Childhood memories, photographs, films, books, Joseph Beuys, Christian
Boltanski, Marlene Dumas, Annette Messenger, Gerhard Richter, Luc Tuymans....

Craft/Technology: What is the difference?
>Craft seems to indicate a skill - the means of using a technique to draw,
paint or sculpt - the initial response to a thought, message or idea.
Technology is an application - the means to reproduce/copy the original drawing
or image (which might have been created by hand).

Which techniques do you use?
>At present I draw and then using photocopying techniques develop the image.

Are these the techniques that you have always used?
>No, currently they are just the means which facilitate the creation of images.
Though drawing remains the essential part of my visual language.

>22.1/From a series for 'Catch 22' by Joseph Heller for the Folio Society Illustration Awards

>22.2/From a series inspired by 'Staring at the Sun' by Julian Barnes

>22.3/From a series for 'Catch 22' by Joseph Heller for the Folio Society Illustration Awards

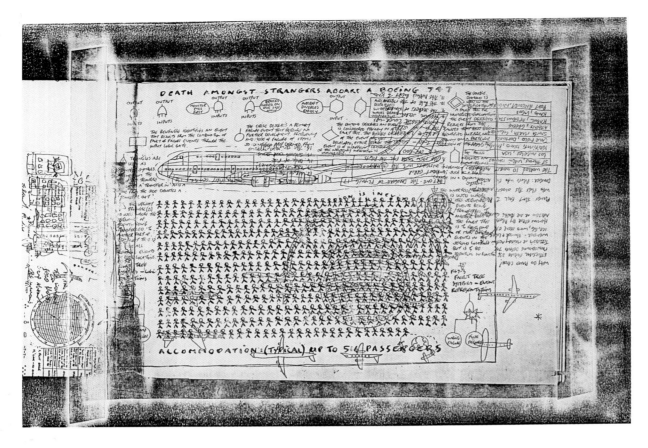

>22.4/From a series inspired by 'Staring at the Sun' by Julian Barnes

From: Steff Plaetz / To: The Author

What do you use as a job title?
>Artist/illustrator.

Why do you do what you do?
>It's what I want to do to make a living.

What inspires you?
>Art, music, sport, films, friends and family.

Craft/Technology: What is the difference?
>Crafty technicians make the difference...?

Which techniques do you use?
>Living in a city, daydreaming, drawing, painting, computering.

Are these the techniques that you have always used?
>'Yes m'aam'.

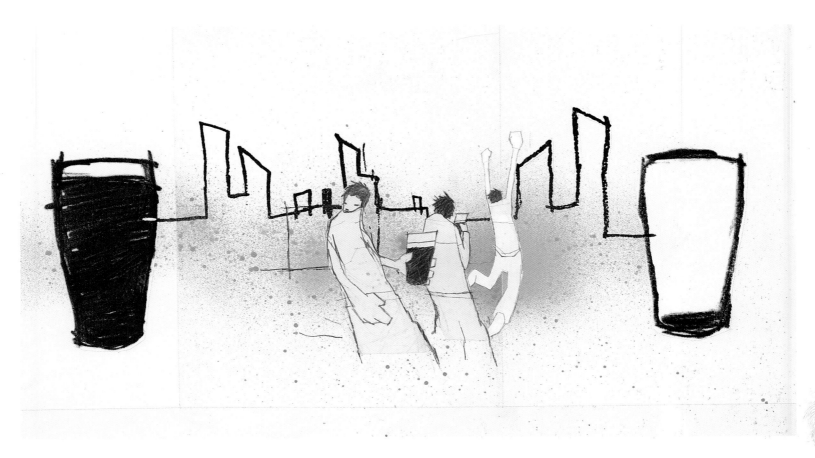

>23.1/Test piece for HHCL

>23.2/Next City Kid 3031

>23.3/Unused flyer design for Don't Panic

From: Eike König 24 / To: The Author

What do you use as a job title?
>Gebrauchsgrafiker.

Why do you do what you do?
>Because I like to do it.

What inspires you?
>Everything.

Craft/Technology: What is the difference?
>Are there differences?

From: Ralf Hiemisch 25 / To: The Author

What do you use as a job title?
>Illustrator.

Why do you do what you do?
>I like it and it pays my rent.

What inspires you?
>The things around me.

Which techniques do you use?
>Painting, photos, computers, model-making.

From: Marco Fiedler 26 / To: The Author

Why do you do what you do?
>I have never thought about that.

What inspires you?
>Everything.

Craft/Technology: What is the difference?
>There is no difference.

Which techniques do you use?
>Any technique that helps me to realize an idea.

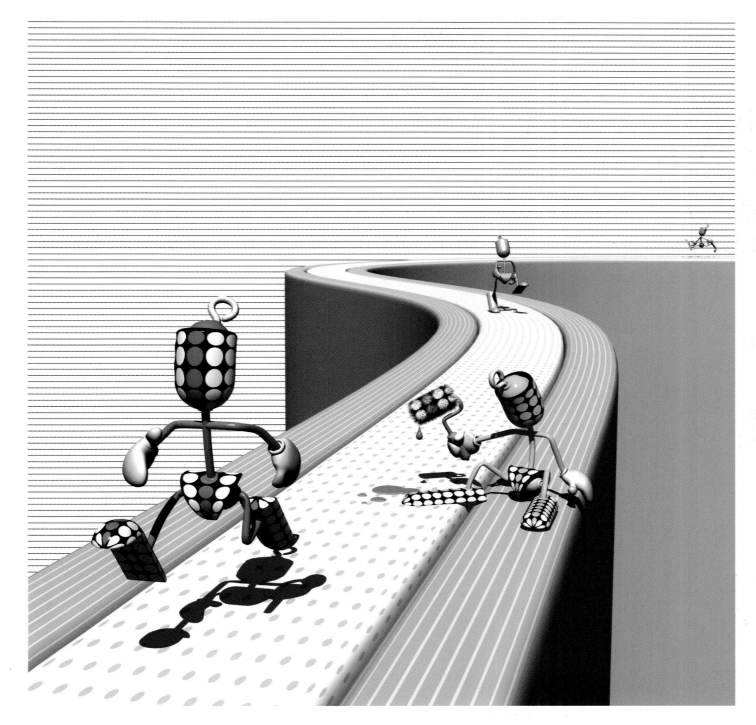

>25.2/Niedlich

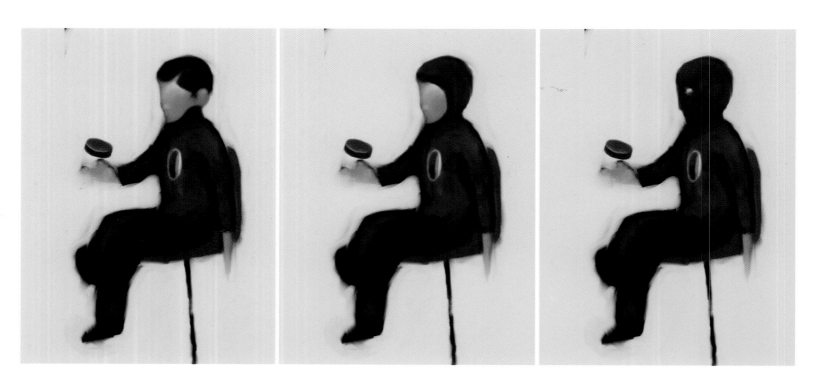

>25.3/Puppenmann

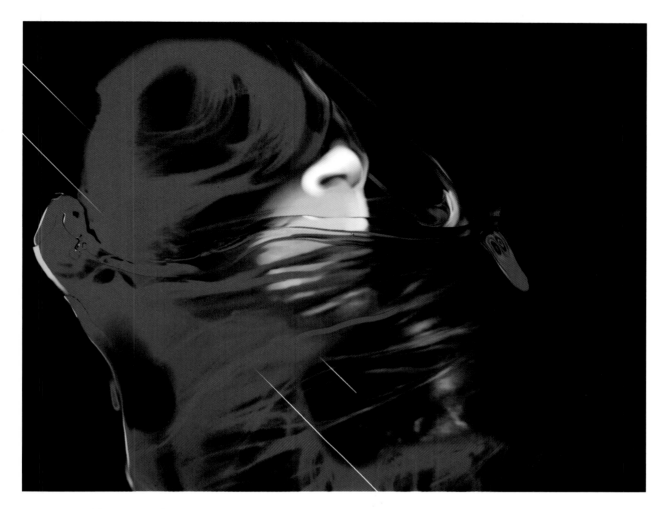

>25.4/Metallstar Klein

>24.1/25.5/Lieb Subraum record sleeve

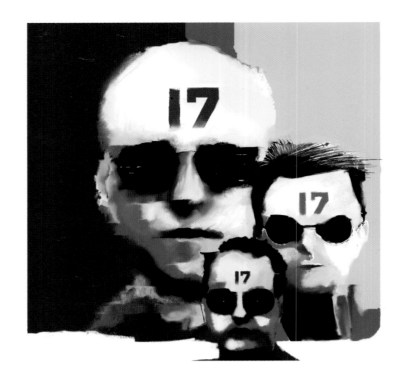

>24.2/25.6/Heaven record sleeve

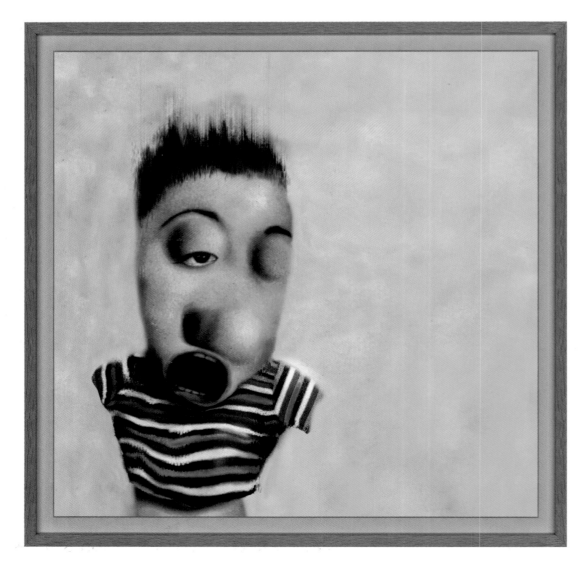

>25.7/Rahmen

BÄNG

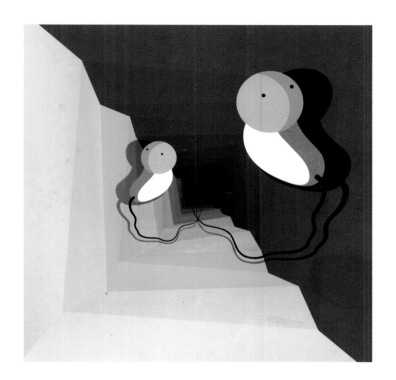

>26.1(above)/Bäng
>25.8(right)/Babies

>24.3/City 2000

>24.4/KayCee: Escape record sleeve

>24.5/KayCee: Escape record sleeve

From: Faiyaz Jafri / To: The Author

What do you use as a job title?
>Digital Artist.

Why do you do what you do?
>I can't imagine doing anything else.

What inspires you?
>Japanese animation, ancient erotic art, comic books, science fiction, cyber punk,
films, tv commercials. The thin line between innocence and perversion.

>Craft/Technology: What is the difference?
A computer is such a powerful image-making machine that if you don't master the
technology of it, it will dictate the concept of your work. Mastering technology,
knowing how to visualize a concept within the boundaries of the software and hardware
of the computer, is fundamental in developing your craft as a digital artist.

Which techniques do you use?
>All my art is solely generated on the computer, I do not use analog material in my
work. As an analogy, my mouse is my brush and my monitor my canvas. My images are
created in 2D and 3D computer software.

Are these the techniques that you have always used?
>They have been for the last ten years.

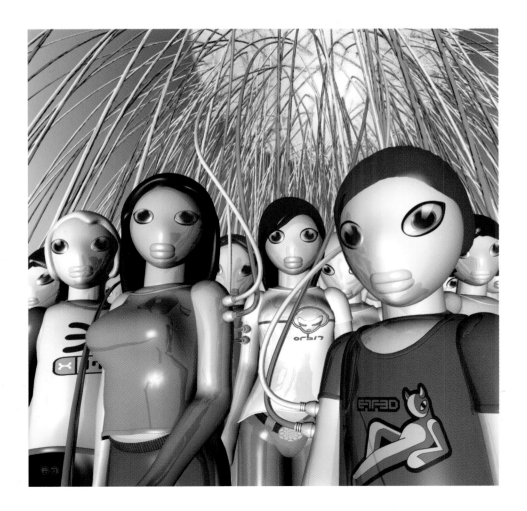

>27.1/Napster,
commissioned by
SPIN magazine

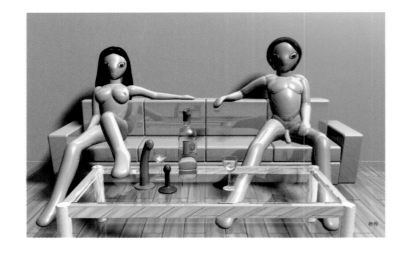

>27.2(right)/Domestic, commissioned by MAN magazine

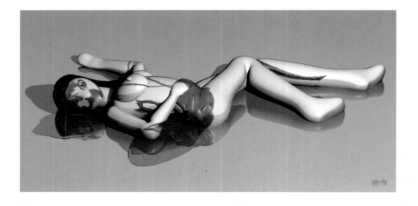

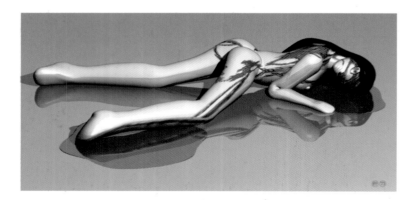

>27.3-27.4(above)/Debora & Delila

>27.5/Pamela, commissioned by Bikini magazine

>27.6/Star, commissioned by Heineken >27.7/Dorothy, commissioned by ROS magazine

From: Akio Morishima / To: The Author

What do you use as a job title?
>Graphic Artist.

Why do you do what you do?
>A long story, but in a word, Fate.

What inspires you?
>Love and fear.

Craft/Technology: What is the difference?
>Technology is the means by which craft is produced.

Which techniques do you use?
>Whatever is quickest; computers are pretty quick.

Are these the techniques that you have always used?
>No, I used to work very slowly.

>28.1/Salarymen, commissioned by Pentagram

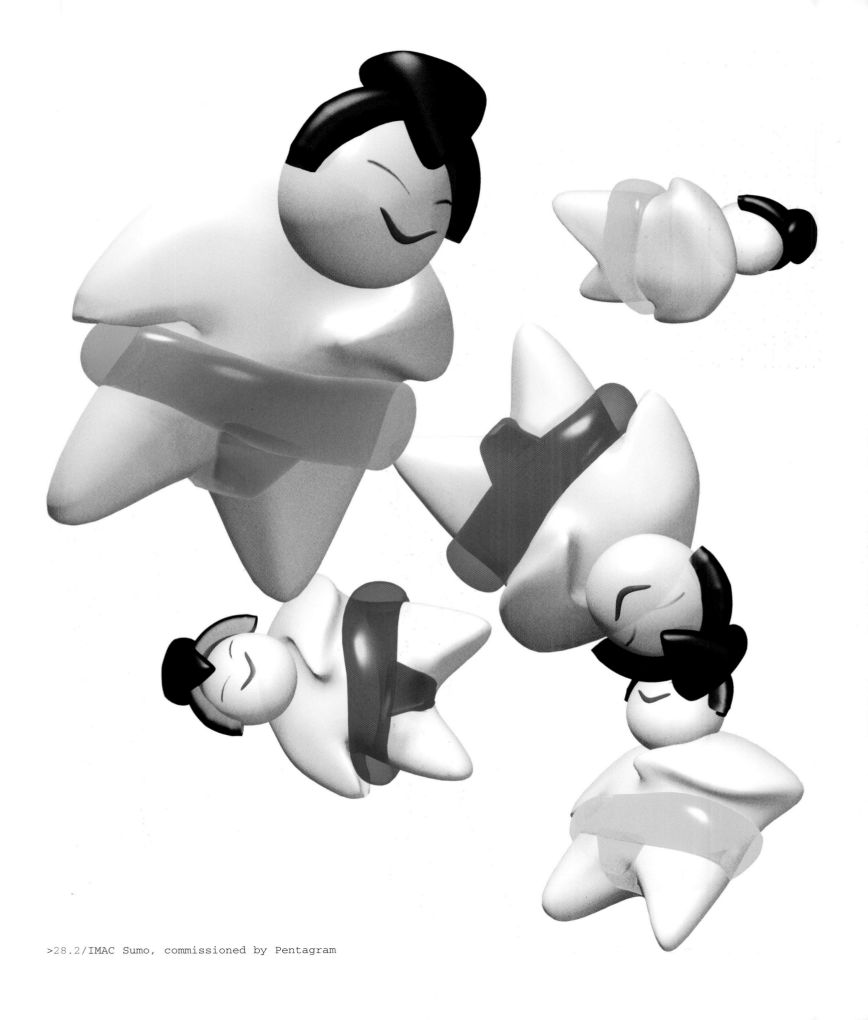

>28.2/IMAC Sumo, commissioned by Pentagram

>28.3/I Love You with My Ford (after JR)

From: Warren Du Preez & Nick Thornton Jones / To: The Author

What do you use as a job title?
>Collaborative Artists.

Why do you do what you do?
> Creative disposition and fulfilment. Collaboration has the benefits of combining a
focus or vision and pooling energy and resources to innovate, inspire and explore new
domains and environments. Oh, who knows? To have fun.

What inspires you?
>Each other, life, an eclectic mix of sub-popular culture, fashion, music, design, media.

Craft/Technology: What is the difference?
>There is no difference; just like an upgrade with a lot more elements to throw into the
equation which doesn't necessarily make it easier. The disciplines honed in the craft
before the technological surge are the disciplines carried through and executed within a
newer medium. We stand for a healthy mix of all disciplines.

Which techniques do you use?
>A healthy mix of humour, combining the disciplines of craft and running with technology.
Alternative light, hair, make-up and styling, photography, art direction, taking in and
out of the craft and the digital domain ultimately ending up with an electronic file of
an image created blah blah blah...hesitant to disclose the activities of the mixing
processes used to achieve the hypergraphic images.

Are these the techniques that you have always used?
>We are not generic repeat operators; techniques are honed, some applied again and
again but no one image has ever the same levels of mix, no matter how small the
differences. They are techniques we have developed, researched, spent hundreds of hours
refining and exploring.

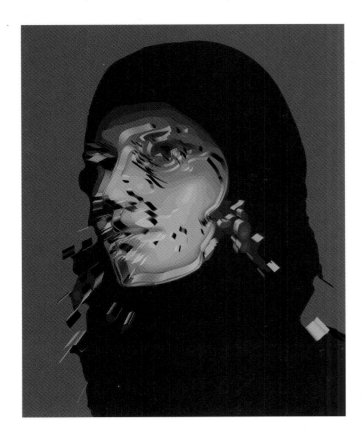

>29.1/Untitled

>29.2(above)/Untitled
>29.3(right)/Untitled

>29.4/Untitled

From: Reggie Pedro / To: The Author

What do you use as a job title?
>I usually go by the title of Painter/illustrator, but Jobseeker will do.

Why do you do what you do?
>I've spent most of my career pondering on this one, and it's a good question to
repeatedly ask myself because it helps me to shape my work and bring some sort of
significance into what I do. It's very easy to just go ahead and create work without
thinking about whether or not it bears any kind of relevance to now, especially with a
medium like paint which is as old as dirt. But I always remember a tutor at college saying
that if you have enough belief and conviction about what you do then no one can tell you
anything. But additionally, I see nothing wrong with doing stuff for the sake of doing it.

What inspires you?
>Inspiration is often difficult to pinpoint because I rarely rely on one source for
inspiration, and also quite a lot of what I produce in my work comes with the actual
working process, so for instance I could start with a single image on a blank canvas and
build a piece around it. But I do read for inspiration sometimes, and I like to collect
short, significant wordings or statements; poetry and short stories can be a source of
inspiration, but most importantly I carry small sketchbooks around with me in which I keep
a lot of my visual information and these are often vital blueprints for my paintings.

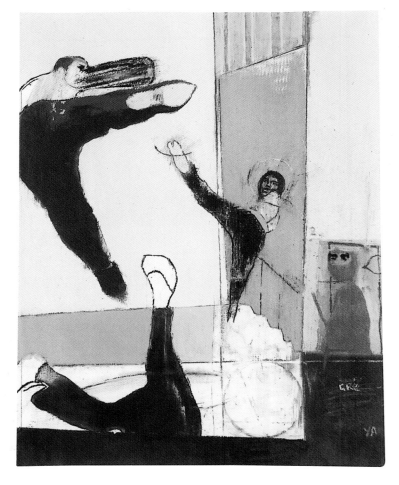

>30.1/Blaze >30.2/Bruce Lee

Craft/Technology: What is the difference?
>I'm not sure why you aim this question at me because I don't think I would
be seen as either a craftsman or someone who uses much in the way of
technology, but I was always told that a craftsperson is someone who adapts
what they do to the industry in one form or another in contrast to the artist
who creates useless objects (with emphasis on the word USE). I suppose
technology is one of the vehicles that carries craft. I would say that the
craft is the making of the object and the object itself, and the technology is
what enables us to do it.

Which techniques do you use?
>I use just about any drawing tool I can lay my hands on - drawing has always
been important in my work. I use various printing and transferring techniques,
oils, acrylics, household paints and sometimes photography. But maybe what
you're interested in is the actual application of these mediums. The problem is
that I never really stick to one way of working; I try to approach a problem
from as many different angles as necessary, so the technique normally depends
on the nature of the work.

Are these the techniques that you have always used?
>I've always drawn; painting came a bit later and the print techniques are
fairly recent.

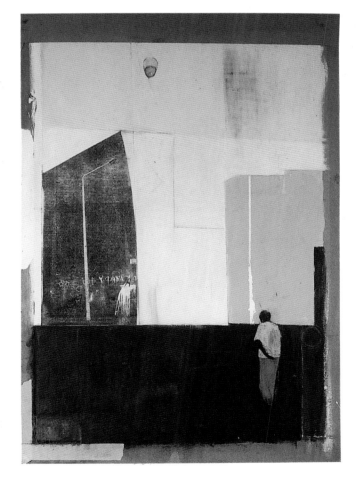

From: Kate Gibb / To: The Author

What do you use as a job title?
>Screenprinter...illustrator.

Why do you do what you do?
>Because I love it! I'm still discovering new techniques and learning, which
keeps me inspired (and basically I wouldn't know what else to do!).

What inspires you?
>Lots of things...people...locations...photography...tv!

Which techniques do you use?
>Mainly screenprinting...photographic and stencil. Currently moving into
photography and Photoshop as a way to achieve more varied results on screen.

Are these the techniques that you have always used?
>No! I was trained as a textile designer which involved a lot of paperwork,
painting and printing on to fabric and wallpaper.

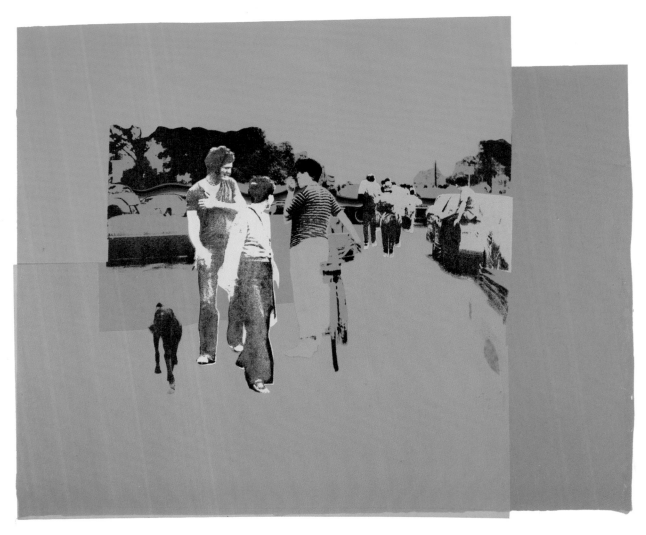

>31.1/Chemical Brothers: Hey Boy Hey Girl record sleeve

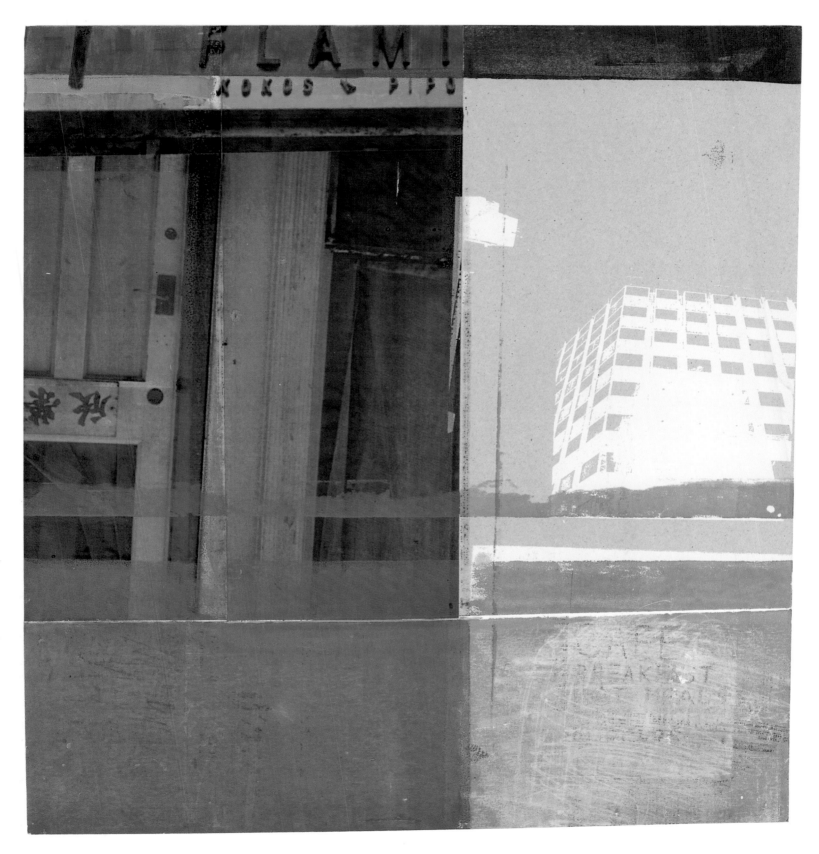

>31.2/Mono record sleeve

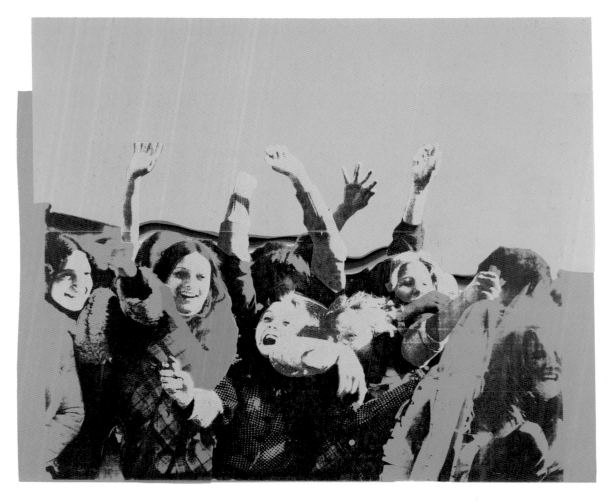

>31.3/Chemical Brothers: Surrender inner record sleeve

From: Alan Baker / To: The Author

What do you use as a job title?
>Painter/illustrator.

Why do you do what you do?
>Because I feel like it.

What inspires you?
>Good stories and bad photo albums.

Craft/Technology: What is the difference?
>Nothing.

Which techniques do you use?
>Nancy Kominsky.

Are these the techniques that you have always used?
>No.

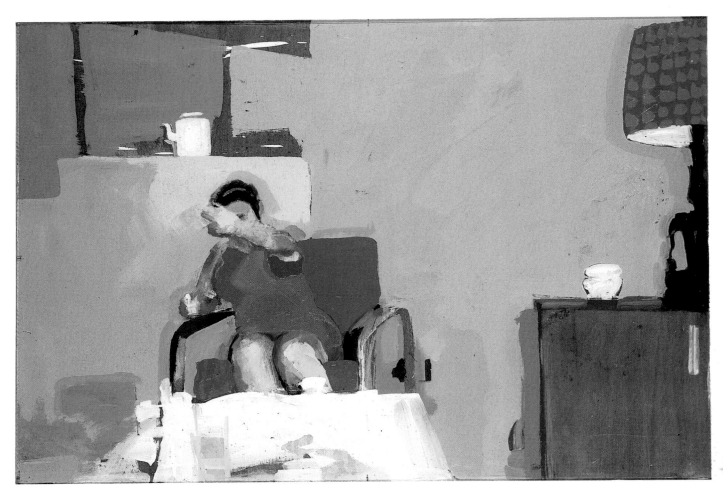

>32.1/Camera Shy Lady

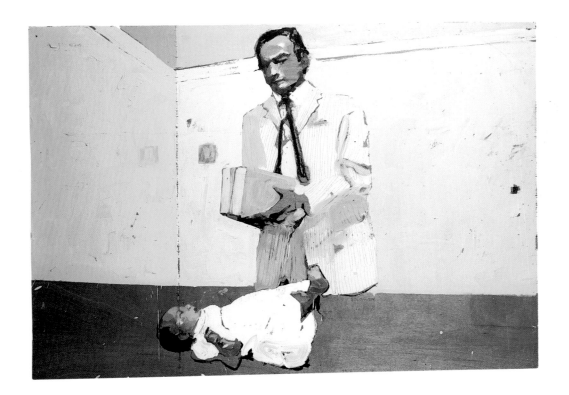

>32.2/Solomon

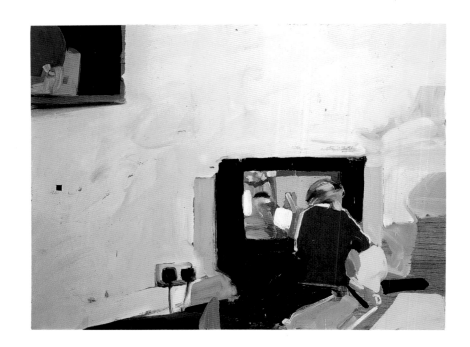

>32.3/Edie and Ernie

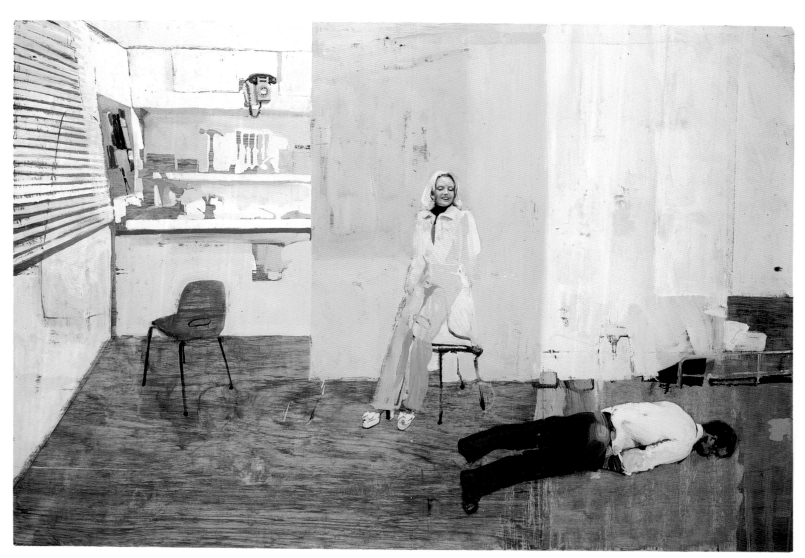

>32.4/Horizontal Man

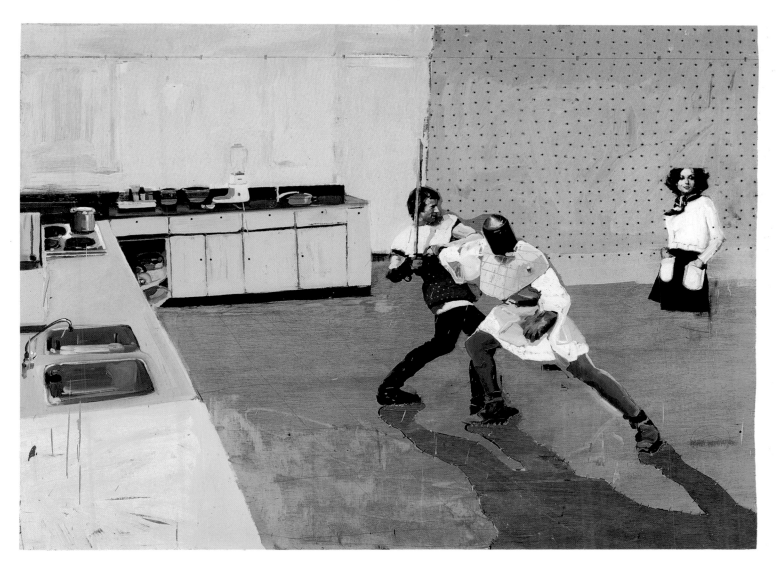

>32.5/Men Fighting in a Kitchen

From: Nick Higgins / To: The Author

What do you use as a job title?
>While I'm being paid, I think it is illustrator.

Why do you do what you do?
>I like to find different ways to describe things that I am interested in.

What inspires you?
>Geography, geology and geometry.

Craft/Technology: What is the difference?
>Craft had an option involved.

Which techniques do you use?
>Illustrator and Photoshop, using the tools which resemble most closely the way I
would have drawn or used collage previously. The simple tools, rather than the filters
and effects.

Are these the techniques that you have always used?
>No. They are at most analagous to my previous way of working. The physical experience
of materials is missing in working on a computer, but this is a reasonable trade-off
when set against the range of processes made available at high speed at home. It has
meant that the appearance of my work has changed completely.

>33.1(top right)/Mash
>33.2(above & right)/Deutsche Bank, commissioned by Frost Design for Nokia in-house magazine

>33.4/Blossom

>33.5/Gas Trees

From: Shiv / To: The Author

What do you use as a job title?
>That depends on who I'm talking to.

Why do you do what you do?
>Because it's what I do best.

What inspires you?
>It's rather who than what.

Craft/Technology: What is the difference?
>Craft can exist without technology, but technology cannot exist without craft.

Which techniques do you use?
>It depends on the project I'm working on but usually 35mm photography and Photoshop.

Are these the techniques that you have always used?
>No.

>34.1/Amber

>34.2/Pressure

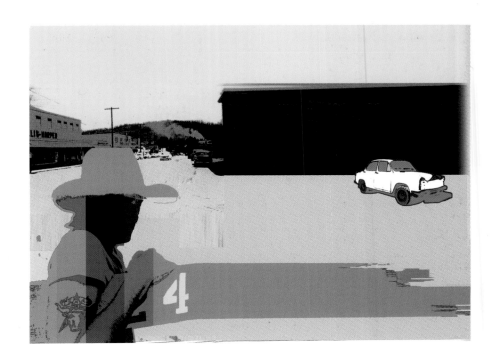

>34.3/Cowboy

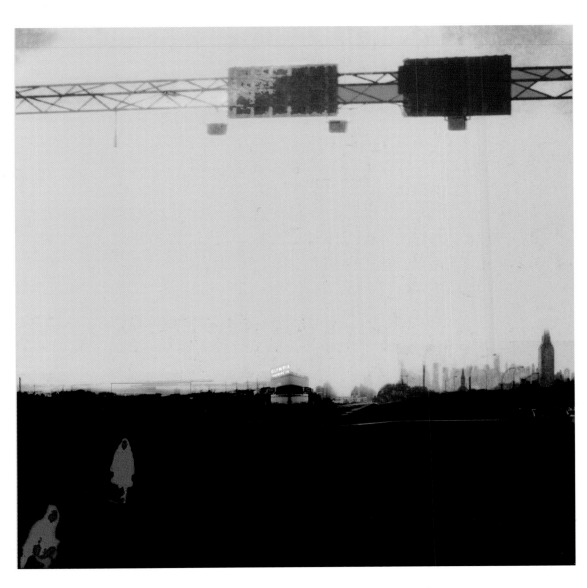

>34.4/Front

From: René Habermacher / To: The Author

What do you use as a job title?
>Illustrator.

Why do you do what you do?
>Reproduction and multiplication was always very interesting to me. I like to work
for a big audience. My work being displayed for thousands of onlookers thrills me.

What inspires you?
>History, architecture, fashion.

Craft/Technology: What is the difference?
>It's all a question of perceptive faculty. If you have a good command of your tools
you can work in as masterly a way with your hands as on the computer. That makes no
difference. But it's always good to have an analog base to build on. The greatest
danger in working completely digitally is a lack of atmosphere in the final piece.

Which techniques do you use?
>Japanese ink, water-colour, computer.

Are these the techniques that you have always used?
>Starting out working very traditionally with Japanese ink on water-colour paper,
I developed my own technique on that basis, adding colours in layers. In the process
of redefining the scans for reproduction, I realized the potential possibilities in
overworking the drawing on the computer. Within the last two years this has become
a strong element of the final result.

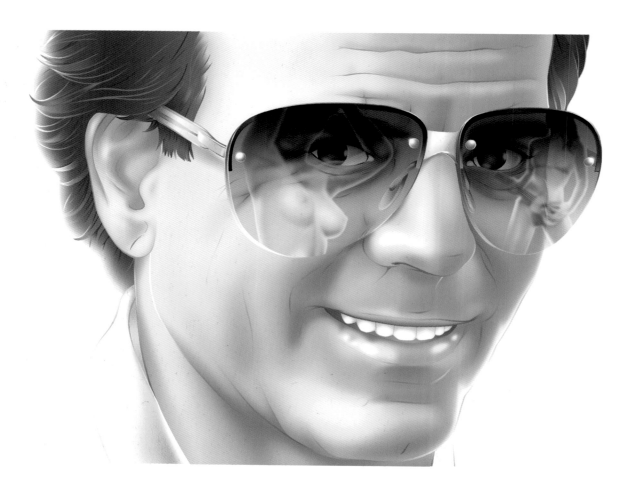

>35.1/Julio

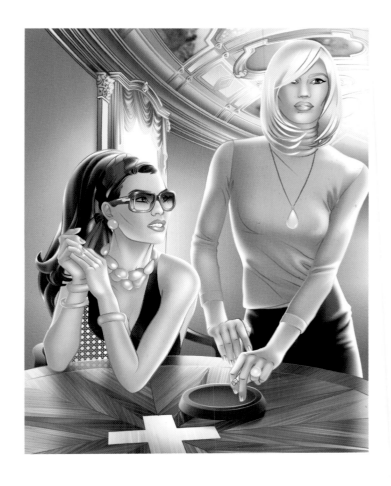

>35.2(right)/Burn Baby Berne
>35.3(below)/Oriana Fallaci's Nieces

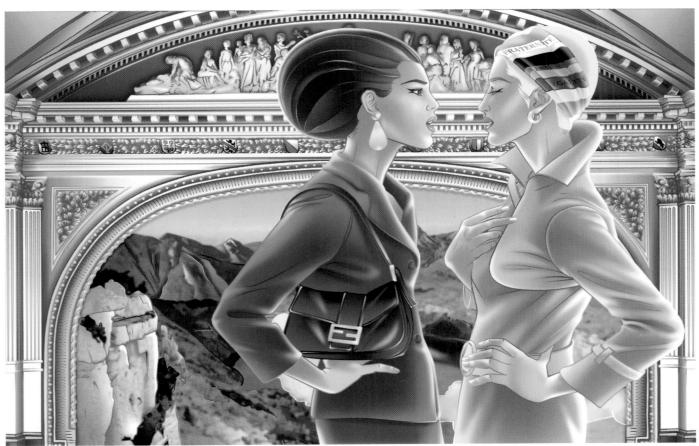

From: Jasper Goodall / To: The Author

What do you use as a job title?
>Illustrator (but I hate how it sounds - so eighties. I just can't think of
anything better to call what I do).

Why do you do what you do?
>My simple answer is that I do what I do because it's all I can do and I'm good at
it. My complex answer goes something like this: I think being an artist is
sometimes a way of asserting your identity in the world; sometimes the need to do a
piece of work comes from wanting to put a personal emotion across, wrapped up
invisibly in an image. Other times it's as selfish as wanting to produce something
that will wow people - a kind of search for celebrity. But I often still think I
should have been a forest ranger....

What inspires you?
>Lots of things inspire me, not all of which, unfortunately, ever get a chance to
come across in commercial work. I'll list some of them: Helmut Newton, sexy women,

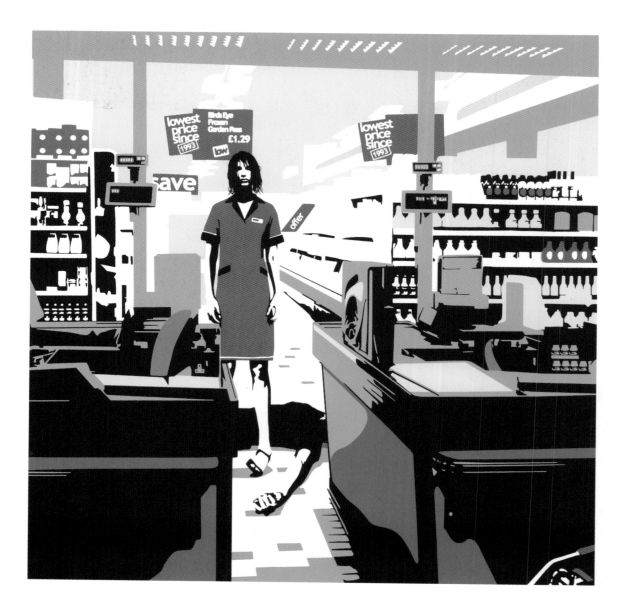

landscape photography, stuff you can do with computers, odd things that I hear or see (if I had one wish it would be to have a camera installed in one of my eyeballs).

Craft/Technology: What is the difference?
Absolutely none – a computer is the same thing as a paintbrush or a screen print bed: a tool. Technology can't produce great art and design by itself; you still need talent and visual awareness to direct its capabilities.

Which techniques do you use?
>Essentially I use the Mac as a technological way of screen printing which, along with stencilling (with car spray paint), was the technique I used before I owned a Mac. The same processes apply: make a selection and fill it.

Are these the techniques that you have always used?
I have always used the same way of tackling a picture (mentally); working out what colour goes in what shape. It's just that the tools have changed. People still ask me if this or that is a screen print; in my head it kind of is, it just took half the time and I didn't need a massive, dirty studio.

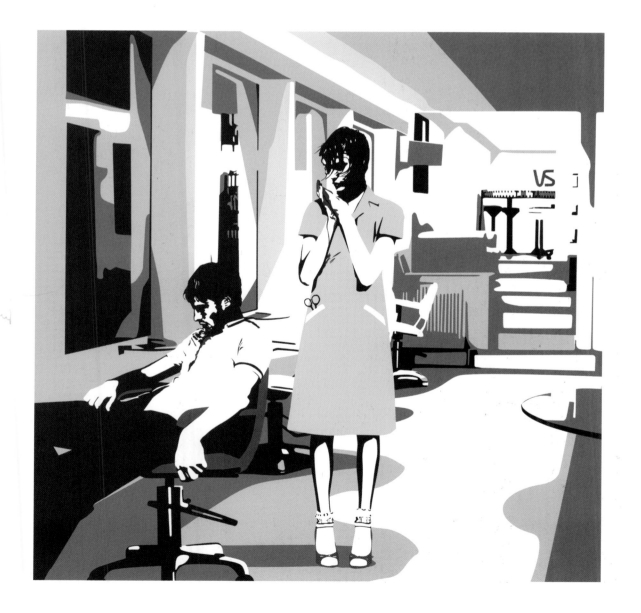

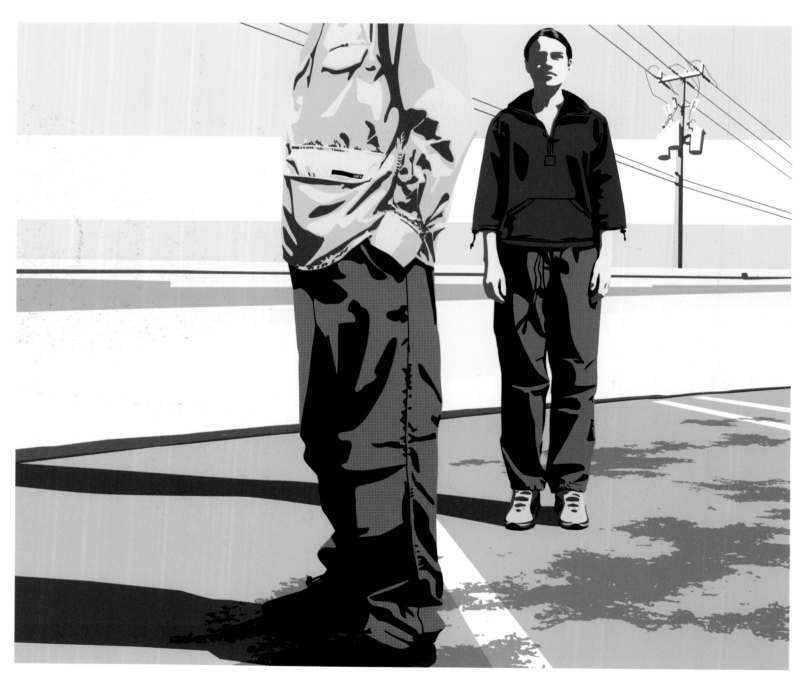

>36.3/Levi's All Duty nationwide point of sale

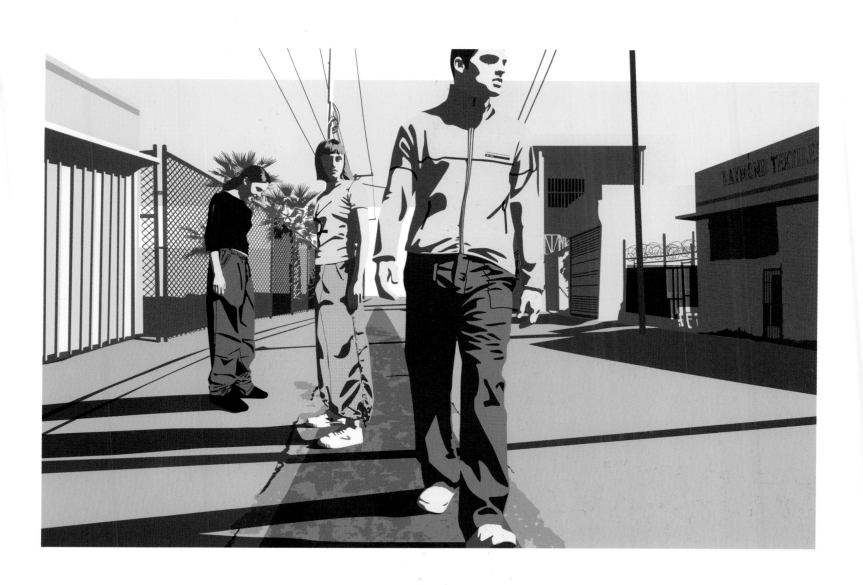

>36.4/Levi's All Duty nationwide point of sale

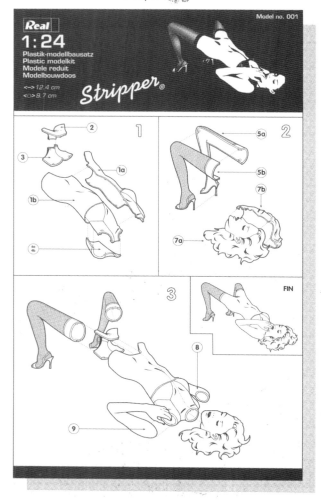

>36.5/Airfix Stripper 1

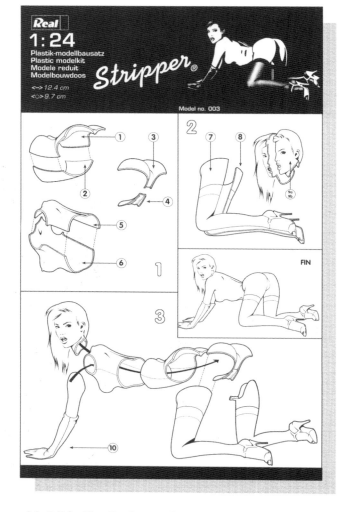

>36.6/Airfix Stripper 2

From: Tim O'Riley / To: The Author

What do you use as a job title?
>Artist.

Why do you do what you do?
>Habit.

What inspires you?
>Random objects, things I encounter every day, science, the unexpected.

Craft/Technology: What is the difference?
>Technology appears to blur the distinctions between one thing and
another but it's the ideas that really make the difference.

Which techniques do you use?
>Mostly 3D modelling, drawing.

Are these the techniques that you have always used?
>For quite some time.

>37.1/Untitled, commissioned by Salon News. Art Director: Martin Perrin

>37.2/Untitled. Creative Director: David Mickelwright

>37.3/Untitled

>37.4(above)/Untitled
>37.5(right)/Untitled

From: Kristian Russell / To: The Author

What do you use as a job title?
>Illustrator and art director (fashion illustrator).

Why do you do what you do?
>I've always drawn, ever since I was two years old. I was always told by my friends and
family that I was gifted and that made me very confident of my ability. Extroverts get
on stage, writers can work 48-hour shifts when they're in the groove, musicians find
expression through lifestyle and hedonism...I'm quite happy to let colour and lines
create other dimensions. I'm interested in art that forms its own rules and its own
little world. If it entrances then you're on to something. Animation (digitally
produced) is something I'm looking into more and more as I find moving images and sound
add another dimension. I also enjoy collaborations; with fashion stylists, art directors
and photographers. Not as a rule but it's a way of developing your senses.

What inspires you?
>Music is very important but really anything that's dynamic and funky (in the sense that
it doesn't take itself too seriously yet has a very strong character). A lot of that is
simply about not compromising: Iggy Pop, Perry Farrell, Alexander McQueen, Oliver
Mourgue, PJ Harvey, Stravinsky, William Blake and even the Sex Pistols are all about
that. Bohemians or avant-garde characters. I find architecture, interior design and
fashion equally powerful. But at street level, if someone has the guts to stick out and
work intuitively then I find it hard not to be inspired by that.

Craft/Technology: What is the difference?
>Craft is all about the self: it was previously about ability but more to the point it's
what you bring yourself to the table. It doesn't matter if it's polished or untutored,
it's valid if it's your own ideas. Anyone can do rip-offs of other people's ideas.
Technology for me is a means to an end: you can build faster vehicles but someone still
has to drive them well enough not to trash them. Recently it's all been about speed and
the internet but in the old days technology was about improvement. In the sixties it
represented an advancement, in the eighties, technology substituted for soul. Two
different eras, two different ideals. So craft would be soul, technology would be
advancement.

Which techniques do you use?
>Most of my images stem from pen-and-ink line drawings that I scan and put together in
the computer. Colour and space is often worked out before but not meticulously planned –
I like to be wowed and surprised by what I see as I continue working with the image on
screen. Once the image is ready I simply send it as a printer-ready file to repro or
clients by email (or CD). I usually know how the colours and lines will behave in print.

Are these the techniques that you have always used?
>No. (...the pretentious bit...) Fine art is all about creating a piece. A piece to be
bought and owned. Commercial art isn't about ownership, it's already bought when it's
created. You don't own commercial art, it gets seen in a magazine or an ad. So what do
you have to concentrate on if you're working on a commercial level? Dynamics. A few
years ago (around 1997) I incorporated computers into my drawing and found the clean
areas and clarity really aesthetic. I could recolour in an instant, rebuild drawings
totally, rescale and crop images in any way I wanted. I got more and more interested in
deconstructing drawings and creating them almost entirely digitally by cutting and
pasting together drawn elements. What I'm essentially interested in today is retaining
the original 'idea' and the dynamic feel that you only ever get in a sketch. Once you
start a third or fourth version of the drawing you've rationalized and torn away all the
mistakes and raw power that was there from the start. What's left is a prettier picture
and ideals. James Brown often talked about using the mistakes made in recording sessions
in his music during his 'important' period in the late sixties. He simply thought the
guffs sounded better and harder. It moved him. In a sense he was talking like the fine
artists Jackson Pollock or Monet where the painting wasn't controlled. They were after
dynamics. So I prefer the rougher drawings and ideas, it's as close as you get to oil
painting in digital art.

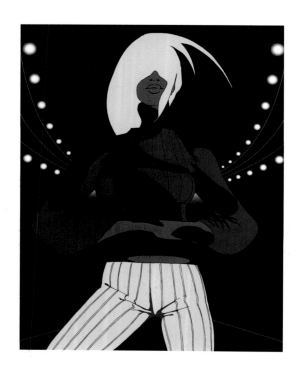

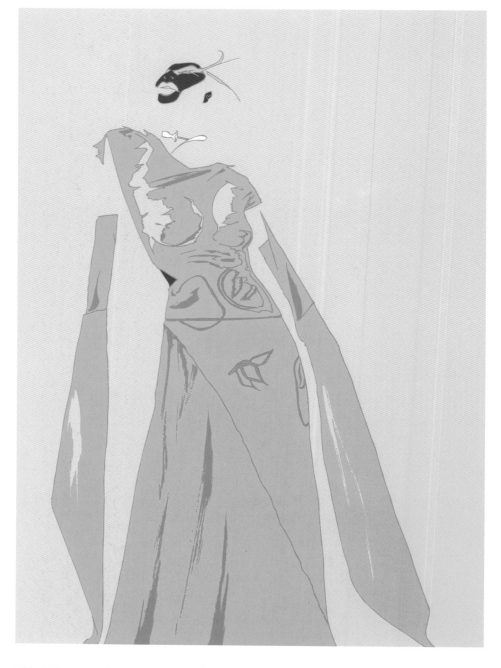

>38.1/Gucci, commissioned by
Nylon magazine

>38.2/Orange Dress, commissioned by
Nylon magazine

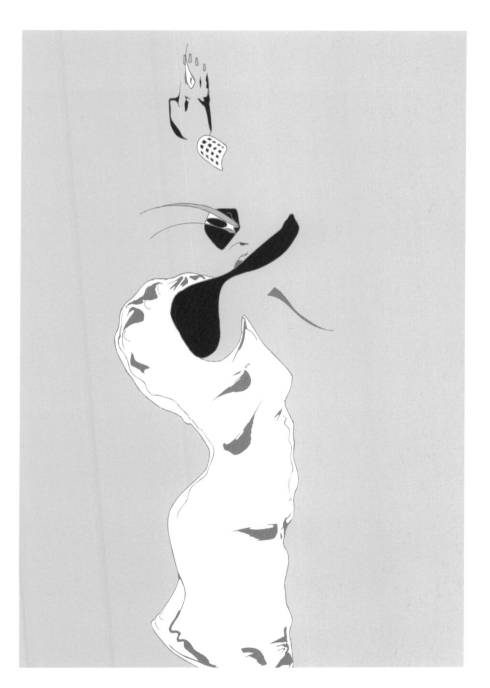

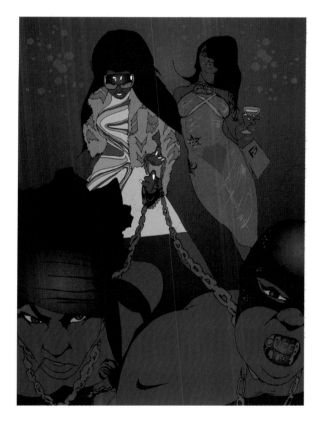

>38.3/Lizard Girl, commissioned by
Nylon magazine

>38.4/Hiphopperz, commissioned by
SPIN magazine

From: Kim Hiorthøy / To: The Author

What do you use as a job title?
>Because I work in different capacities, most often the job is called something
first, and then I'm called what people who do that job are called when they do it.

Why do you do what you do?
>It happened along the way.

What inspires you?
>Other people.

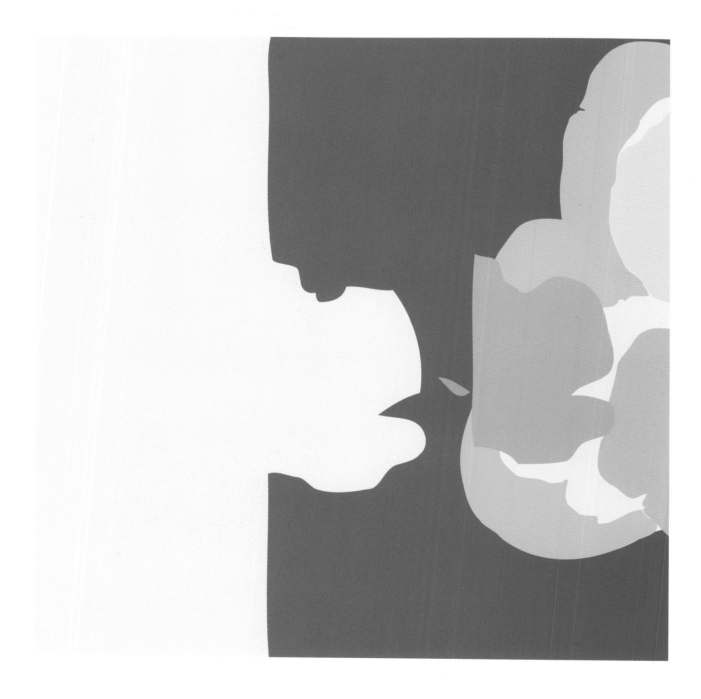

Craft/Technology: What is the difference?
>If feet are technology, then craft can be to run or to tap dance, or to wiggle your toes.

Which techniques do you use?
>Thinking is good, and listening to intuition and learning as you go.

>39.1-39.2(this spread)& 39.3(following spread)/Excerpts from Motorpsycho:
Let them eat cake record sleeve from Tree Weekend, published by Die Gestaltung Verlag

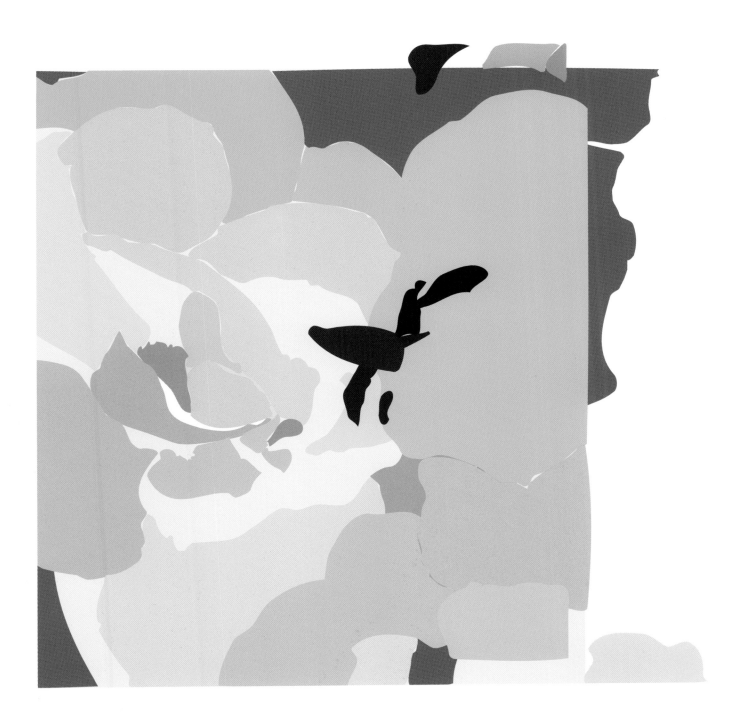

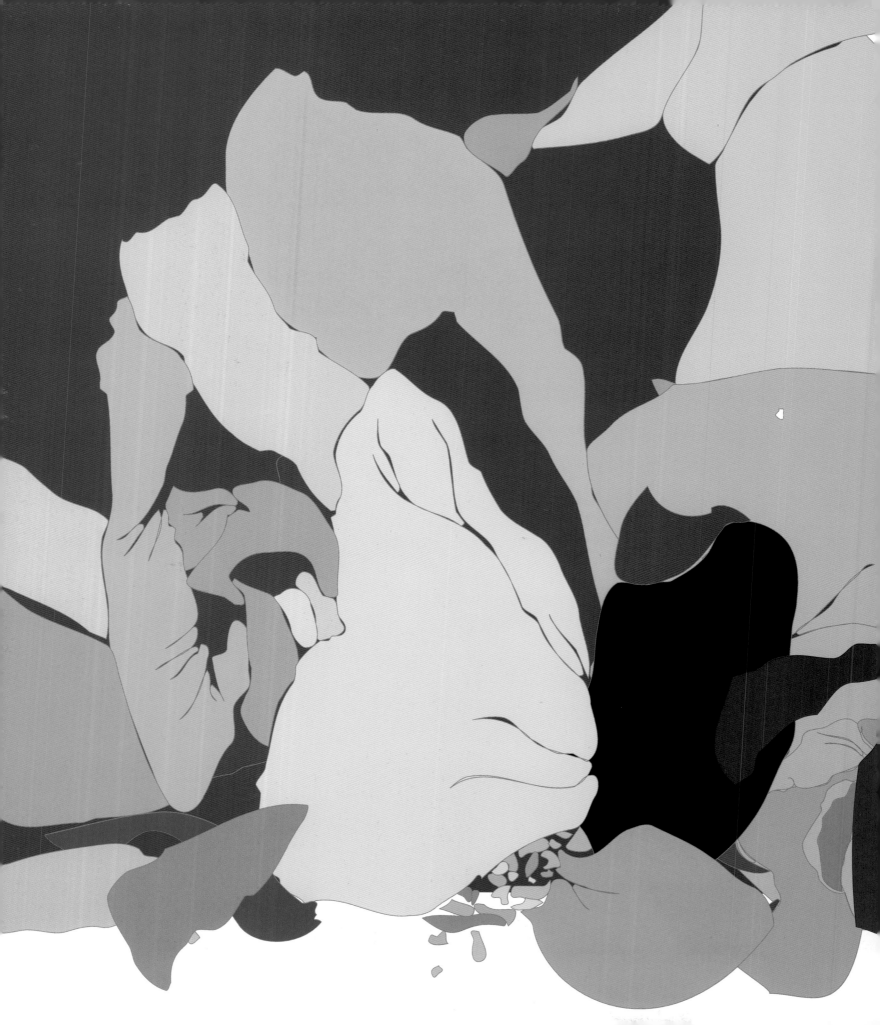

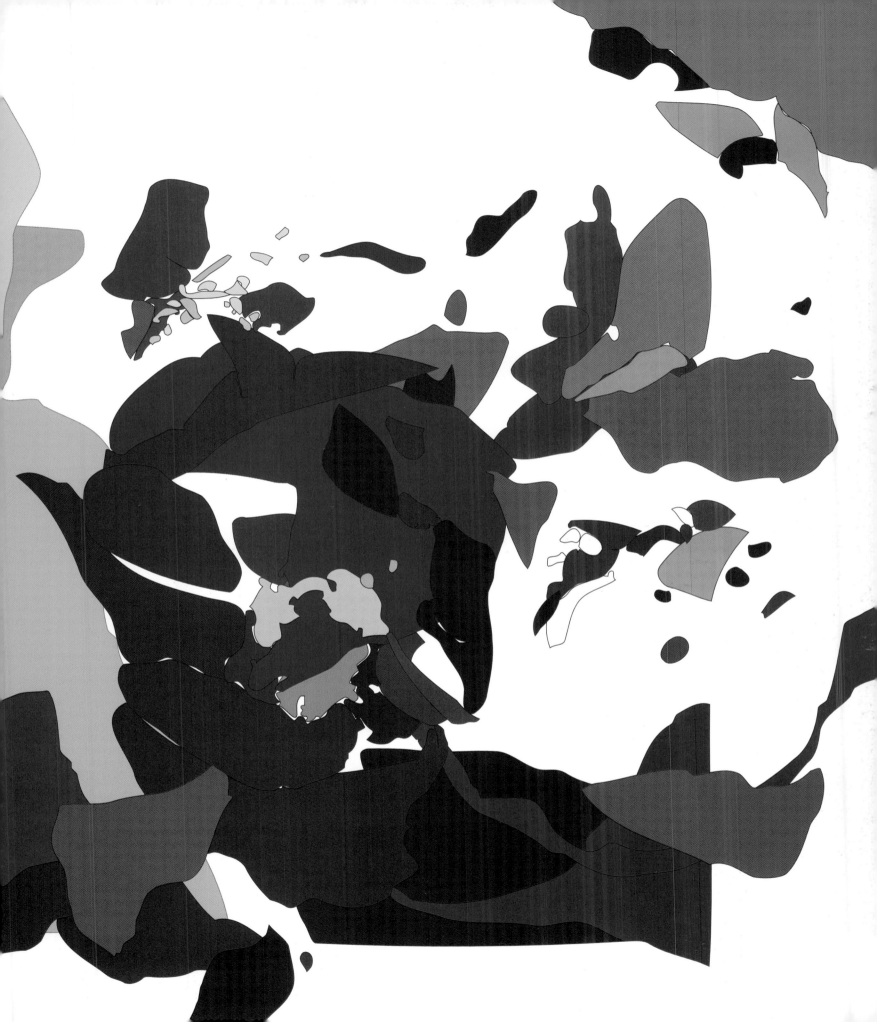

From: Timmy Kucinda / To: The Author

>What do you use as a job title?
Graphic Artist, although I have never really felt comfortable with any
title. I'm always looking for what feels right. My projects usually cover
areas falling somewhere between illustration and design. The thinking and
process of both are one and the same to me. It's all image-making and
story-telling.

>Why do you do what you do?
Everyone needs to make a living. I feel we should all find a way to use our
natural gifts for that purpose. It just feels right, and when I look around
at what other people are doing, no matter what the field, those who stand
out as balanced and happy are the ones who found that place. I find myself
searching for ways to make the commercial art I do say more than is
expected of it. I really try and get personal. Even if it's not immediate
to the viewer, I feel it eventually comes across and hopefully adds to
their experience. I've learned that if I don't agree with what a project
stands for or how it will affect the audience it reaches, then I'm probably
not the right person for the job. Ideally what inspires and interests me
should overlap with the thinking and needs of the client and their vision.

>What inspires you?
Dogs, especially my little guy Munky. I can't explain it. They just put
things in perspective for me, remind me of the genuine goodness that is in
this world. They're extremely in tune with our emotions, and they're funny!
What inspires me the most are the lovely people that I've been fortunate
enough to have around me. They inspire me through the ways that they live,
the ways that they get excited and the humour that comes from their take on
the world. I usually try to include friends in my work when I can, document
the time we are sharing. What these things have in common is that they
affect me on a daily basis, become a part of who I am.

>Craft/Technology: What is the difference?
Technology is a luxury and an incredible tool; it has made things possible
that weren't before. But without craft we risk standing still. Craft is the
vision and the process. To me that is what pushes things. I like to see
strong combinations of the two.

>Which techniques do you use?
I like to play with line weights and line quality. Finding ways and
appropriate times to add a hand-made quality to an image yet have it remain
distinctively electronic. This can be labour intensive but for me it's
worth the million mouse clicks. I've also been forced to figure out ways to
facilitate my colouring process. I think through repetition we all find
what works best for us.

>Are these the techniques that you have always used?
No, it's an ongoing process. Building a library of techniques, with each
new project benefiting from the ones that came before.

>40.1–40.4/Commissioned
by Universal Design

>40.5(top)/Commissioned by Airwalk Snowboards
>40.6(above)/Commissioned by Universal Design

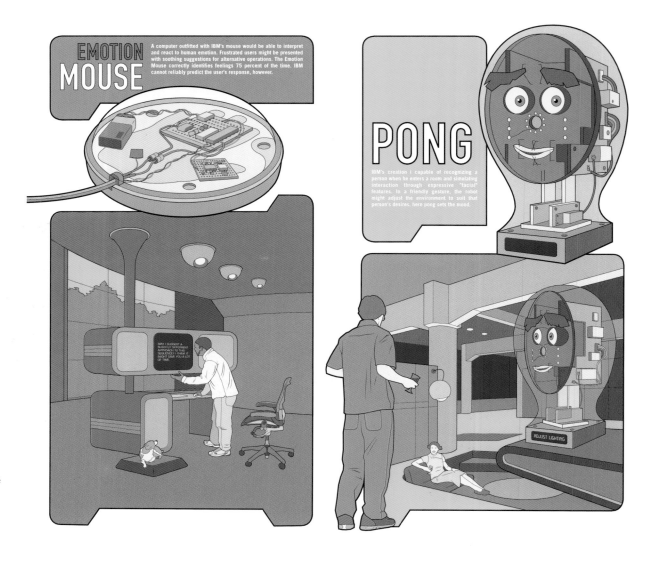

EMOTION MOUSE
A computer outfitted with IBM's mouse would be able to interpret and react to human emotion. Frustrated users might be presented with soothing suggestions for alternative operations. The Emotion Mouse correctly identifies feelings 75 percent of the time. IBM cannot reliably predict the user's response, however.

PONG
IBM's creation i capable of recognizing a person when he enters a room and simulating interaction through expressive "facial" features. In a friendly gesture, the robot might adjust the environment to suit that person's desires. here pong sets the mood.

>40.7/Commissioned
by Metropolis magazine
Art Direction:
Criswell Lappin

From: Kam Tang / To: The Author

What do you use as a job title?
>Designer/illustrator.

Why do you do what you do?
>I'm a masochist.

What inspires you?
>The natural world.

Craft/Technology: What is the difference?
>Craft is the skill and knowledge of an artist, technology is
simply a tool developed to further this.

Which techniques do you use?
>Observing, thinking, drawing.

Are these the techniques that you have always used?
>Yes, in varying degrees depending on the task at hand.

>41.1–41.4/The Ideal Bachelor Pad, commissioned by Arena magazine >41.5(following spread)/
Illustration for the Royal College of Art prospectus. Art Direction: Graphic Thought Facility

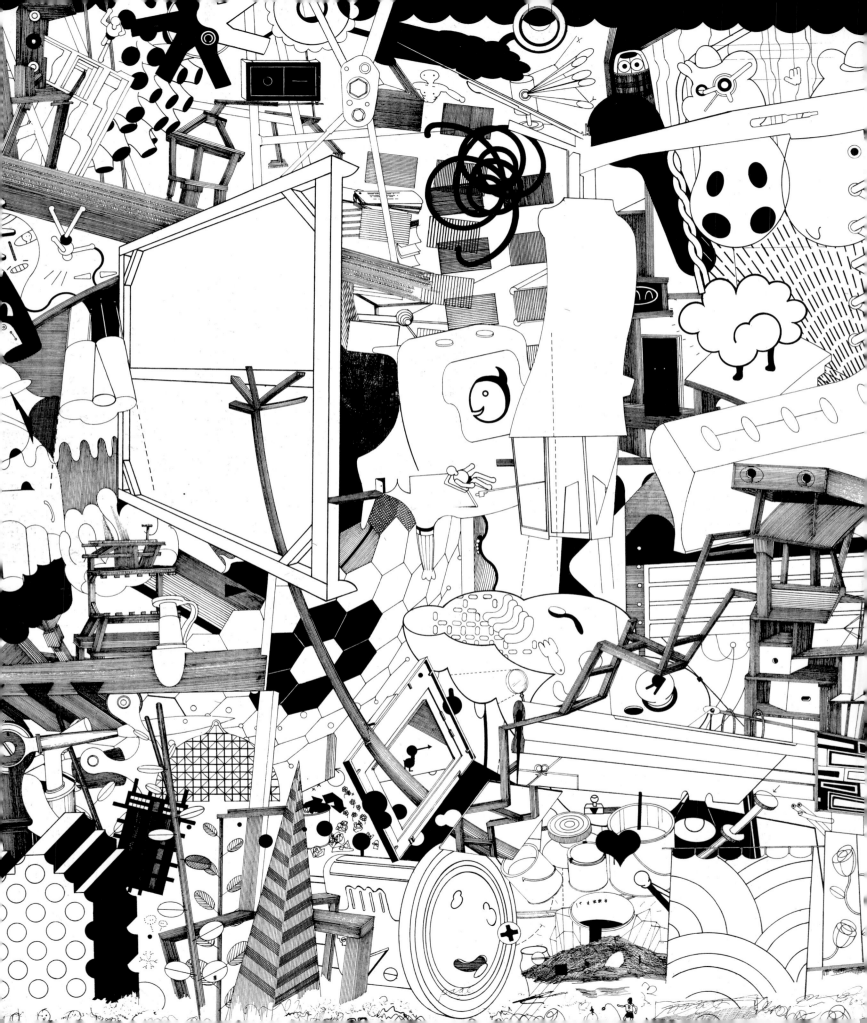

From: Evan Hecox / To: The Author

What do you use as a job title?
>Illustrator/designer.

Why do you do what you do?
>I've always enjoyed drawing and making things. I like seeing my work
published and printed on T-shirts, skateboards, and in books and magazines.

What inspires you?
>Other artists and designers. Music. I also take a lot of inspiration and
imagery from urban environments. I like design work from the pre-1970s when
graphic artists really were both artists and designers. It seems like now
people are either one or the other. I'm most inspired by people who can
integrate real drawing and painting skills into their design work, which was
much more common in earlier decades.

Craft/Technology: What is the difference?
>I think that craftsmanship is really something within a person which can be
applied to either traditional or technological media. It's mostly a matter
of having patience and really caring about what you're doing. I think that
working on a computer makes craftsmanship more automatic in some ways. My
favourite examples of craft are always things that are done by hand, not
digitally, it's more visceral and direct. Technology has the advantage of
being able to reach a wider audience and make creative work more accessible,
which can be good.

Which techniques do you use?
>I used to work only in traditional media. I started using a computer
because I was almost always disappointed with how my paintings and drawings
would look in reproductions. By creating digital artwork I'm able to have
much more control over how a final, printed piece looks. The graphic style
of my digital work is actually very similar to my paintings, but it's a much
better way of working in terms of combining it with print and web design.

>42.1/Loading Dock

>42.2/Crane

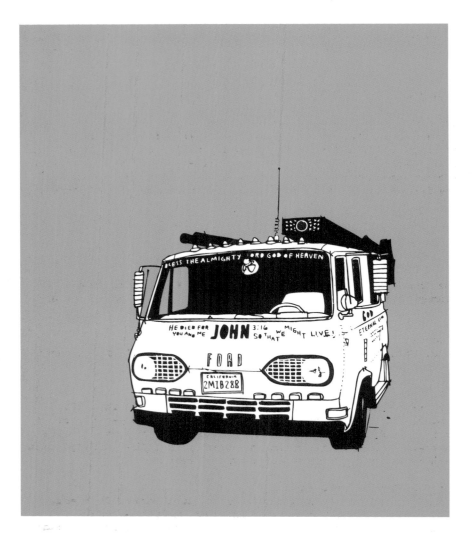

>42.3/Van

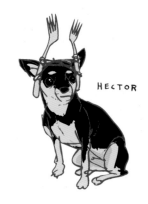

>42.4/Hector

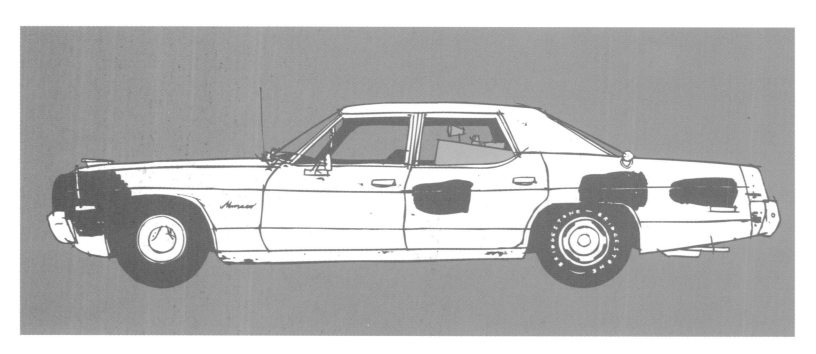

>42.5/Sedan

From: Ian Bilbey / To: The Author

What do you use as a job title?
>I would call myself a designer. Illustration is only a small part of what I do. I design about a hundred posters a year for Paul Smith (Japan); twenty-four per season for women's wear, and twenty-four a season for collection. I am usually sent some colour swatches, and either a theme or some key details. After that it's up to me. I use as much photography as illustration. I have also worked with ceramics, and car companies, and exhibition installation.

Why do you do what you do?
>MONEY.

What inspires you?
>In illustration it would be the likes of Herb Laupin, Savignac, Paul Rand. More generally Charles and Ray Eames, but especially lateral thinkers like I. K. Brunel and Colin Chapman (Lotus).

Craft/Technology: What is the difference?
>None. They are just enablers. There is no particular virtue in either. Ideas and good taste are what counts.

Which techniques do you use?
>Anything that could be done before the advent of Macs. I don't like 'effects'. The computer is a brilliant enabler, but I only use a tiny fraction of its capabilities. I sometimes draw with the mouse - which I find surprisingly natural. Other times I will paint on paper - usually in black - like I was making a screen-print, then arrange them in the Mac. I use pen, scraps of paper, doyleys - all sorts of things.

Are these the techniques that you have always used?
>Yes. I particularly used to like collage. Oddly I think the computer works in pretty much the same way. I only learnt to use the Mac in the last few years. I wasn't interested at college and spent my time doing screen-printing and making films. I taught myself Freehand (which is pretty much all I know) and can now apply old techniques to it.

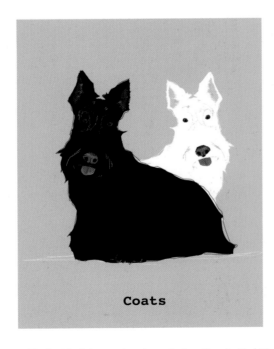

Coats

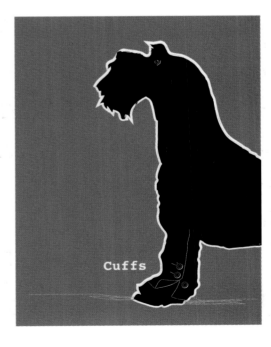

Cuffs

>43.1-43.2/Commissioned by Paul Smith Collection, Japan

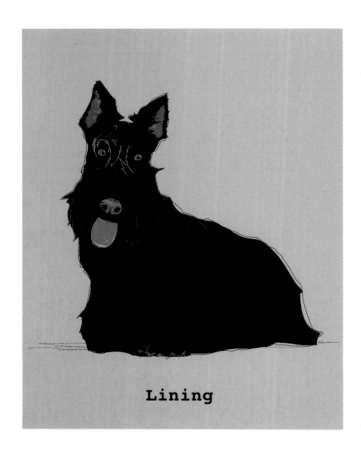

Lining

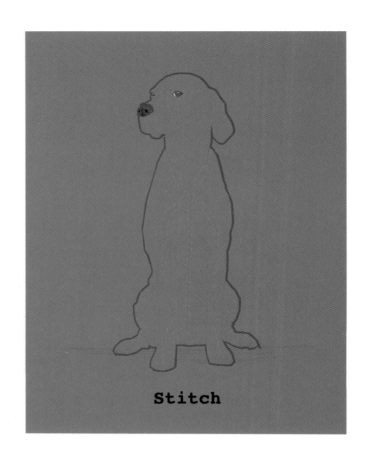

Stitch

Ties

Soft

>43.3-43.6/Commissioned by Paul Smith Collection, Japan

>43.7-43.10/Commissioned by Paul Smith Women, Japan

From: Michael Gillette / To: The Author

What do you use as a job title?
>I've never been comfortable with illustrator, I'm more of an irritator.

Why do you do what you do?
>Because I've got itchy fingers.

What inspires you?
>The whole hot pot-pourri of pop culture.

Craft/Technology: What is the difference?
>For me, craft is the past and technology is the future, but you've got to
know where you're coming from to know where you're going to.

Which techniques do you use?
>I'm always on the look-out for moments of serendipity, so I use a big
variety of techniques to keep things moving. I use the Mac to bring 'em all
together. I'm a total convert.

Are these the techniques that you have always used?
>I used to paint solely in acrylic. I've paid my dues in ye olden ways. I
still paint for exhibitions. It's a good balance. Sometimes it refreshes
your soul to watch paint dry.

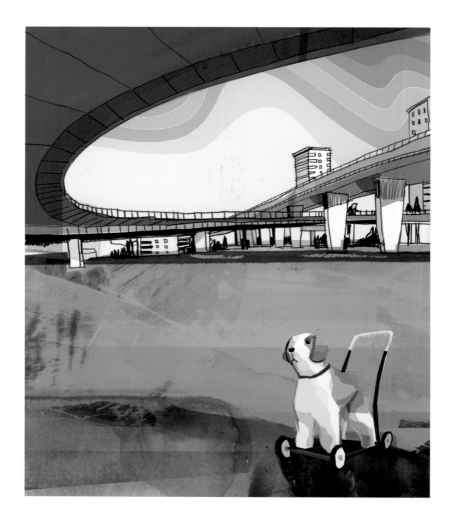

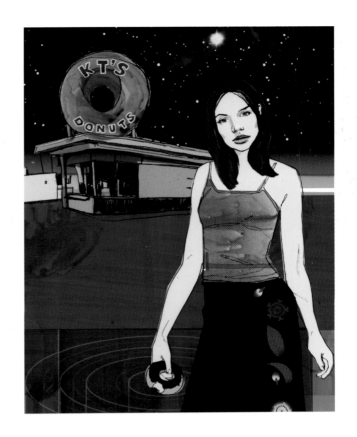

>44.2 (right)/Donut
>44.3 (below)/At Home with Charity

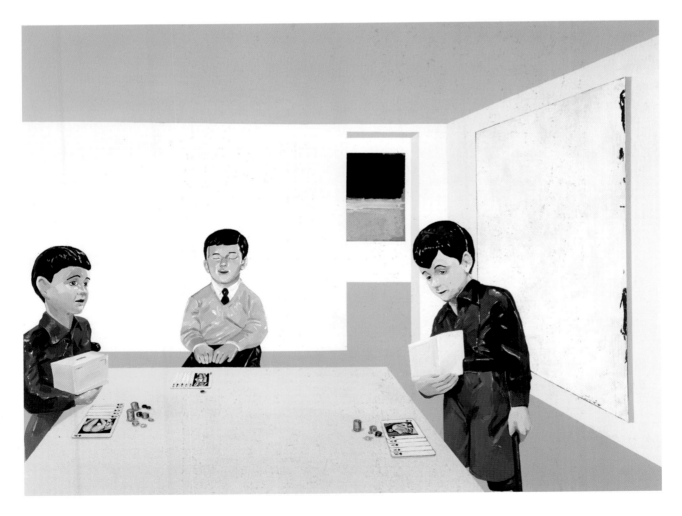

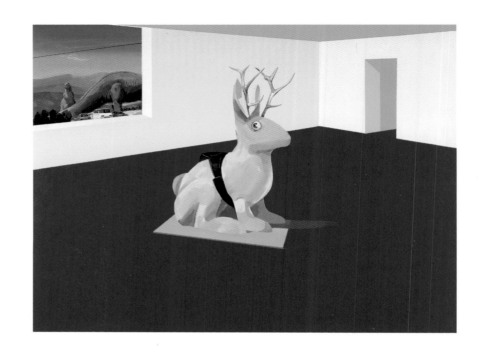

>44.4/The Jackalope

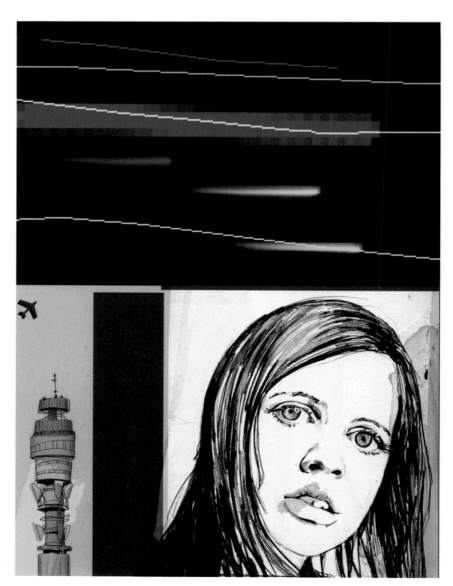

>44.5(right)/London Eyes
>44.6(far right)/React and Then Belatedly Respond

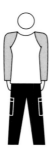

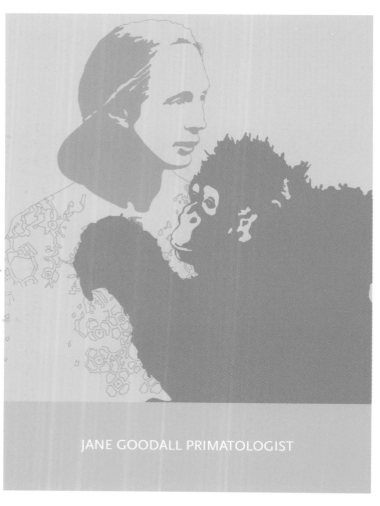

JANE GOODALL PRIMATOLOGIST

JON SPENCER ROCK AND ROLL SINGER

>45.1–45.4/Commissioned by Colette, Paris

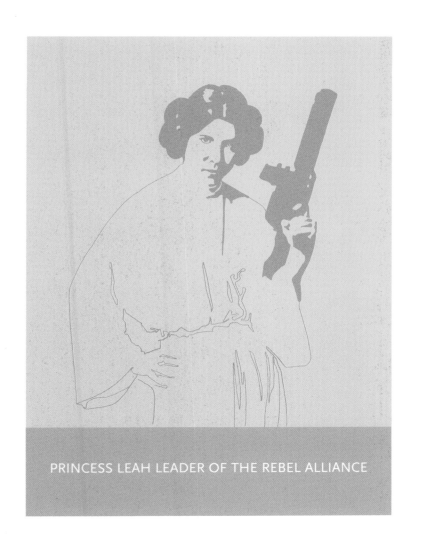

PRINCESS LEAH LEADER OF THE REBEL ALLIANCE

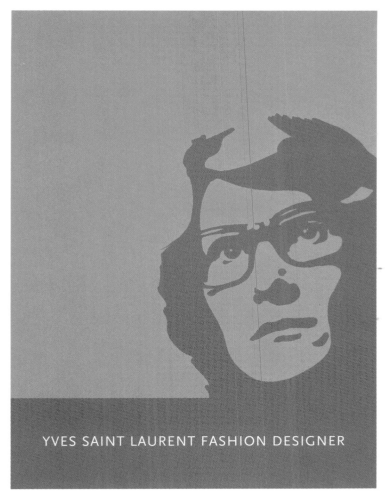

YVES SAINT LAURENT FASHION DESIGNER

>45.5/AIR: Kelly Watch the Stars record sleeve

Published in 2001 by Laurence King Publishing
an imprint of Calmann & King Ltd
71 Great Russell Street
London WC1B 3BP
Tel: +44 020 7430 8850
Fax: +44 020 7430 8880
e-mail: enquiries@calmann-king.co.uk
www.laurence-king.com

A catalogue record for this book is available from the British Library.

ISBN 1 85669 231 0

Printed in Hong Kong

Editor/Art Director: Angus Hyland, Pentagram Design
Assistant Editor: Roanne Bell
Designer: Charlie Smith, Pentagram Design
Introduction: Angus Hyland, Deborah Taffler
Cover Design: Nick Higgins, Angus Hyland, Sharon Hwang, Akio Morishima, Charlie Smith, Nick Turner

Acknowledgements: Akio Morishima, Darrel Rees, Hannah Ford, J. Abbott Miller, Martin Perrin,
Alice Twemlow, Celia Joicey, Paula Carson, Ric Blackshaw, Lucy Bone, Greg Burne, KesselsKramer,
Kinsey, Robert Klanten, Koeweiden Postma, Amanda Mason, Matt Owens, Rick Poynor, Gerard Saint,
Carlos Segura, Alexei Tylevich and Jo Lightfoot, commissioning editor at Laurence King.

Contact addresses:
>Paul McNeil/www.paulmcneil.com >Anthony Burrill/anthony@friendchip.com >Kjeks –
Nina Klausen and Lill-Hege Klausen/www.kjeks.nu >John Maeda/info@maedastudio.com
>Jeff Fisher /J.FISHER@wanadoo.fr >Ian Wright/c/o Heart www.heartagency.com >Alex
Williamson /alex.crooked@virgin.net >Tommy Penton/00 44 (0)795 725 8892 >Shonagh Rae
/big.orange@virgin.net >Miles Donovan/0771 5103673 >Chris Kasch/00 44 (0) 20 8422
2416 >Graham Rounthwaite/c/o Art Department www.art-dept.com >QuickHoney – Nana
Rausch & Peter Stemmler/info@quickhoney.com >Spencer Wilson/0793 263 6845 >Green Lady
- Gary Benzel & Todd St John/info@greenlady.com >Lucy Vigrass/00 44 (0)7941019053
>Paul Davis /www.copyrightdavis.com >Joe Magee/c/o Heart www.heartagency.com >Kinsey
/info@kinseyvisual.com >Marion Deuchars/mariondeuchars@lineone.net >Ceri Amphlett
/00 44 (0)797 474 9889 >Roderick Mills/roderickmills@lineone.net >Steff Plaetz/00 44
(0)7974 453594 >Eikes Grafischer Hort – Eike König, Ralf Hiemisch, Marco Fiedler/www.
eikesgrafischerhort.com >Faiyaz Jafri/faiyaz@bam-b.com >Akio Morishima/akio@btinter
net.com >Warren Du Preez & Nick Thornton Jones/c/o Leonie Edwards-Jones 00 44 (0)20
7734 1110 >Reggie Pedro/00 44 (0)20 8534 7554 >Kate Gibb/c/o Big Photographic bp@big
active.com >Alan Baker/00 44 (0)20 8692 3805 >Nick Higgins/nick.higgins@virgin.net
>Shiv/c/o Big Photographic bp@bigactive.com >René Habermacher/www.never-stop-move
ment.de >Jasper Goodall/c/o Big Photographic bp@bigactive.com >Tim O'Riley/tim.oriley
@bigfoot.com >Kristian Russell/c/o Art Department www.art-dept.com >Kim Hiorthøy/kim
im@online.no >Timmy Kucinda/timmy@dreamlodge.net >Kam Tang/www.kamtang.co.uk >Evan
Hecox/ www.evanhecox.com >Ian Bilbey/www.oyoy.co.uk >Michael Gillette/www.michael
gillette.com >Mike Mills/www.thedirectorsbureau.com

>Angus Hyland by Nick Higgins